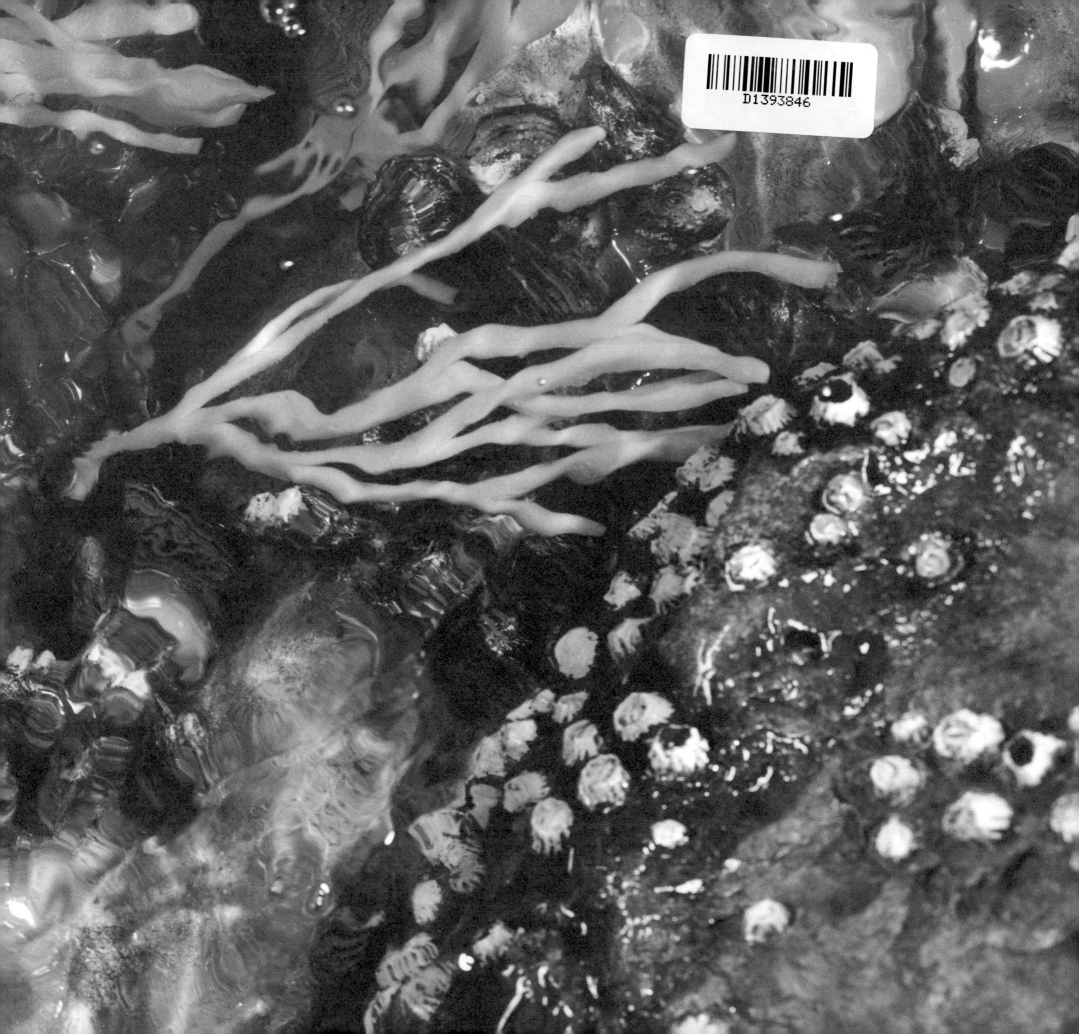

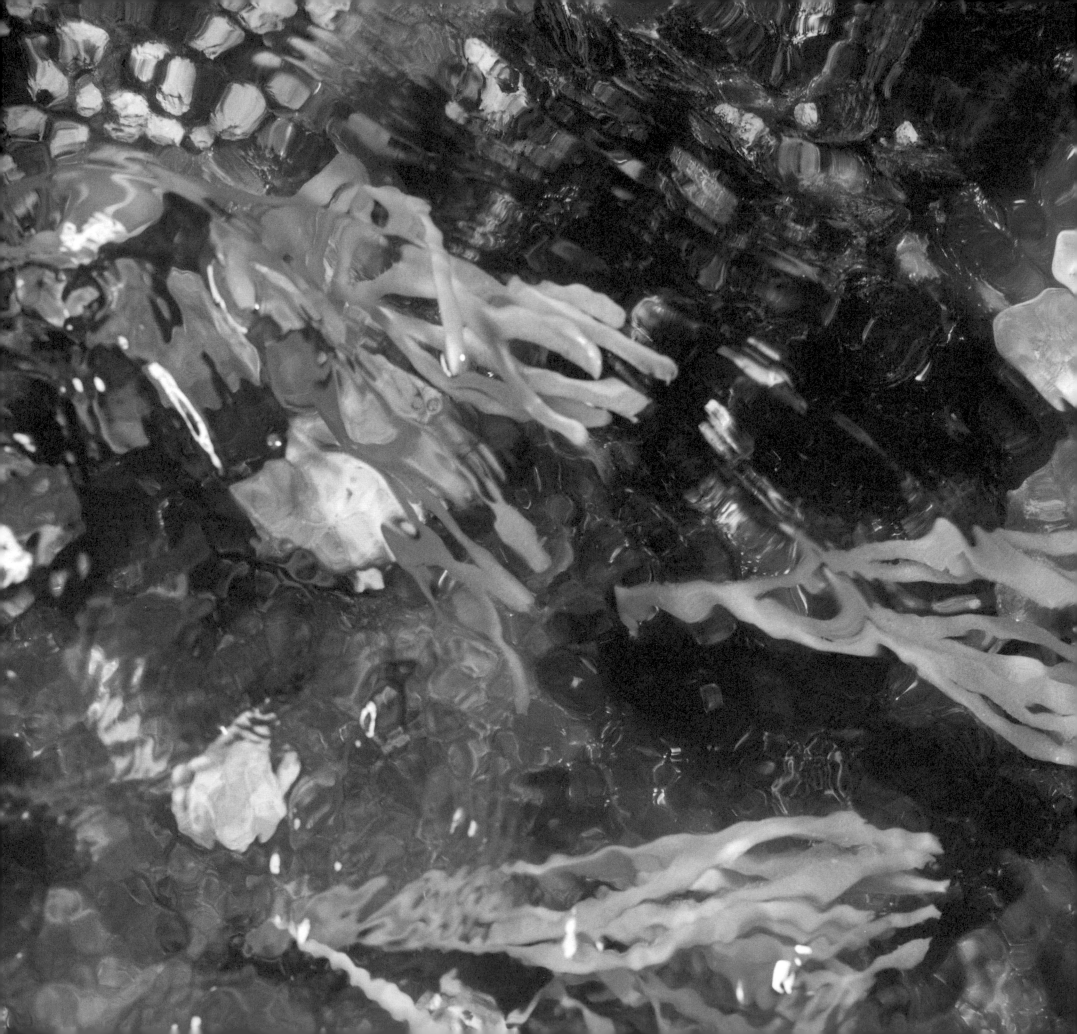

Robert Gober

Organized by Paul Schimmel

Essays by Hal Foster and Paul Schimmel

The Museum of Contemporary Art, Los Angeles
Scalo, Zurich–Berlin–New York

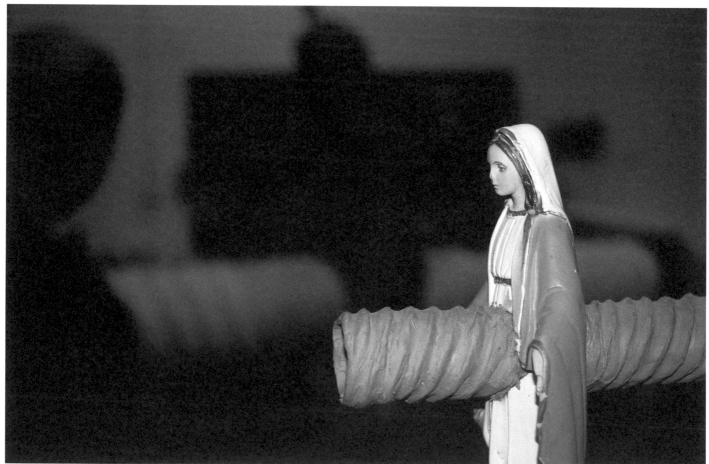

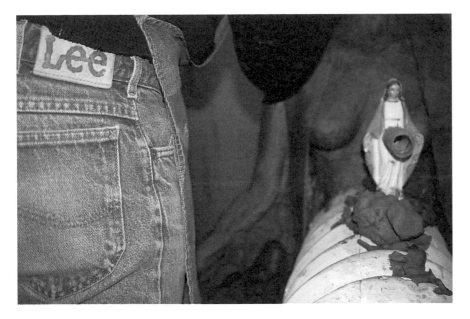

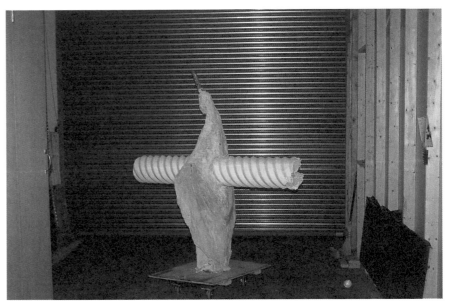

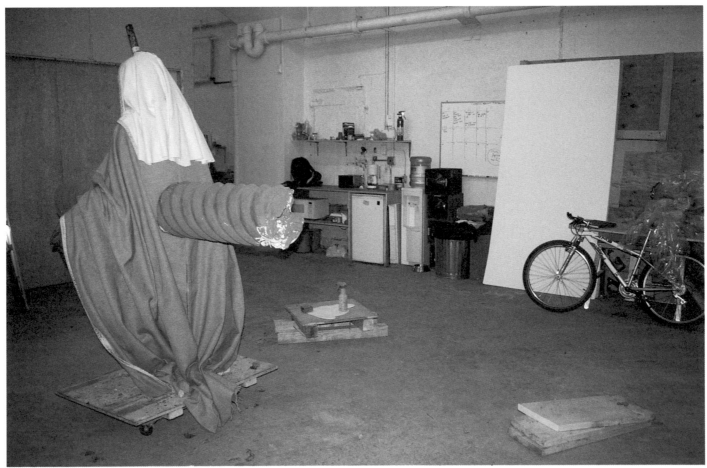

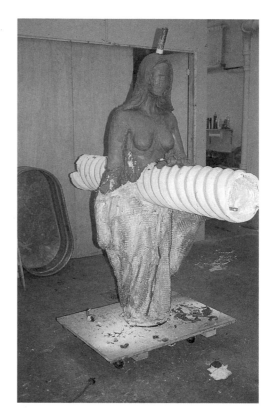

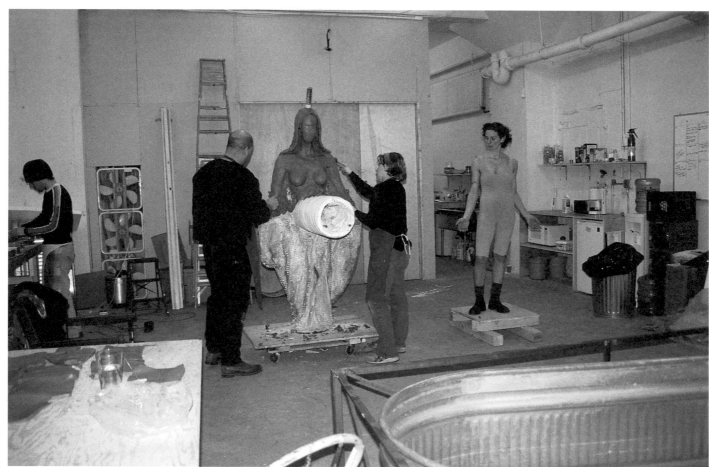

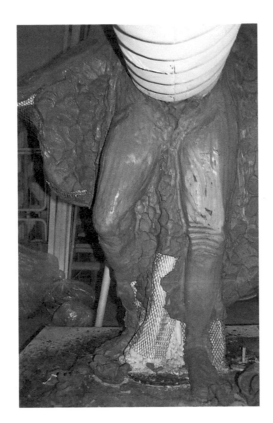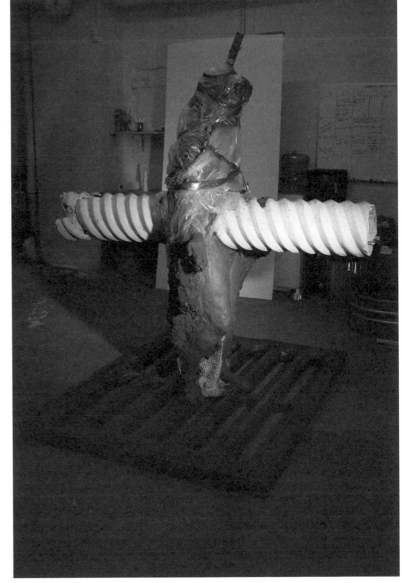

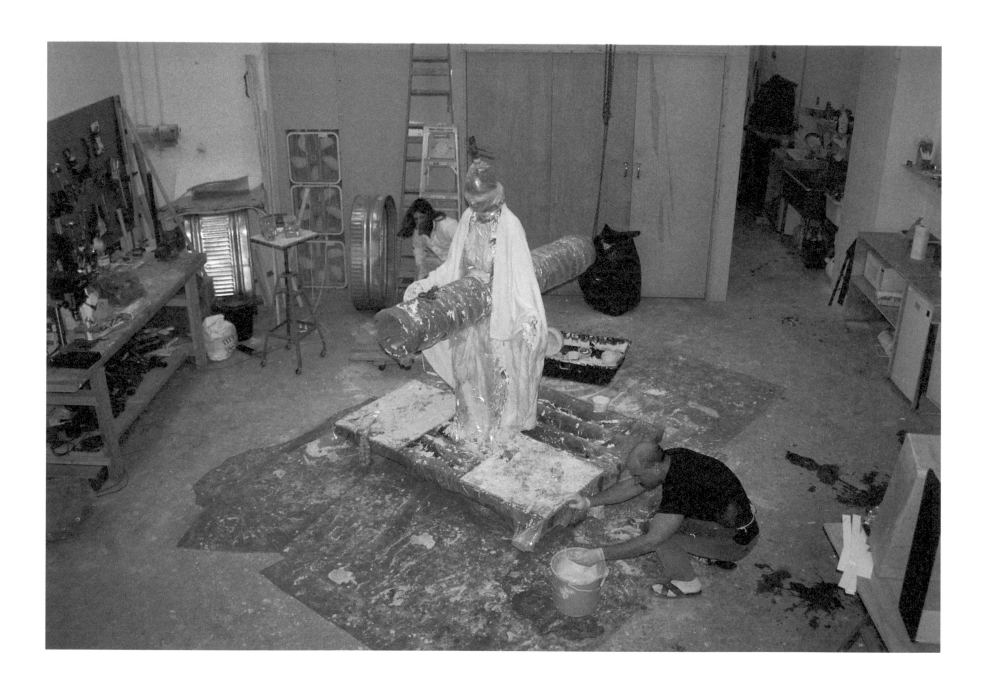

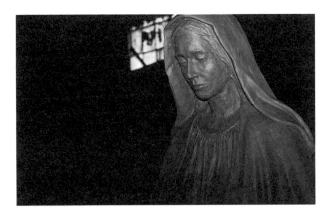
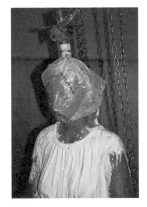

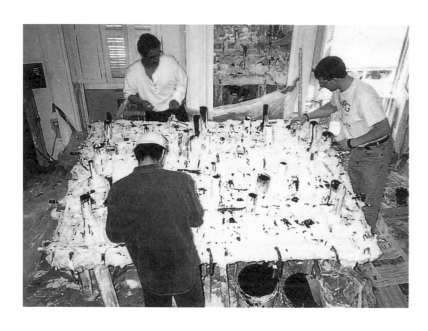

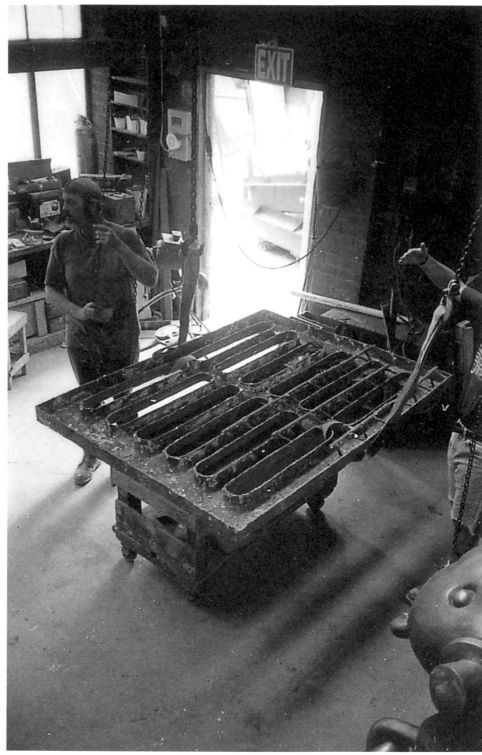

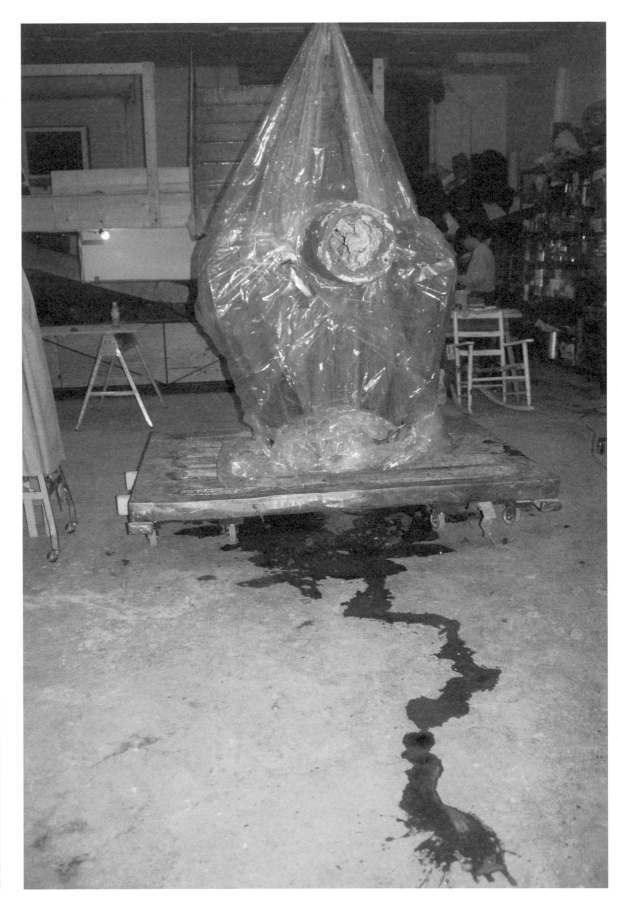

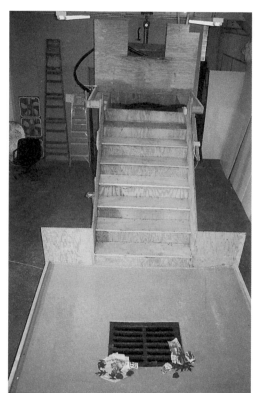

Pick up car.

take truck
to WYA pick
up 2 pipes
bring to 215t

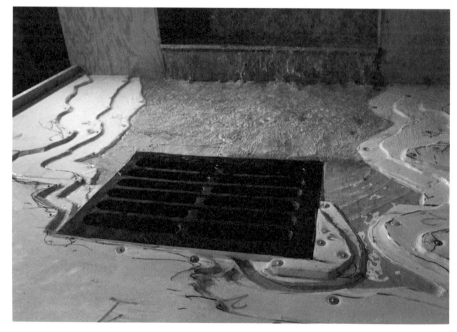

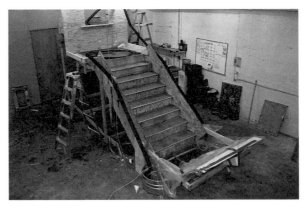
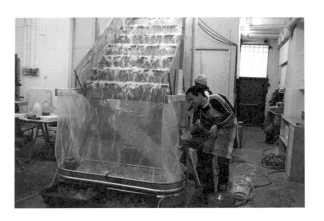

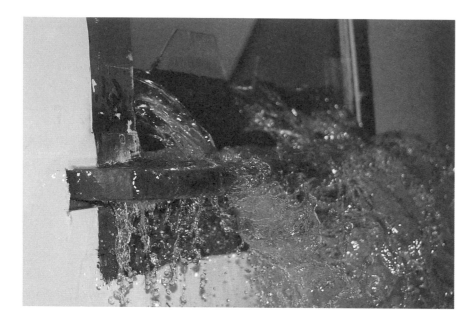

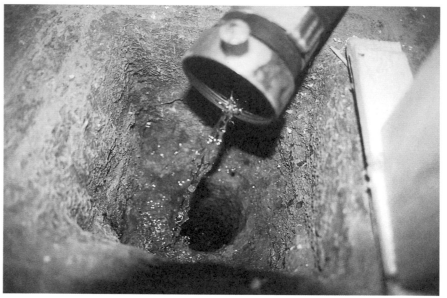

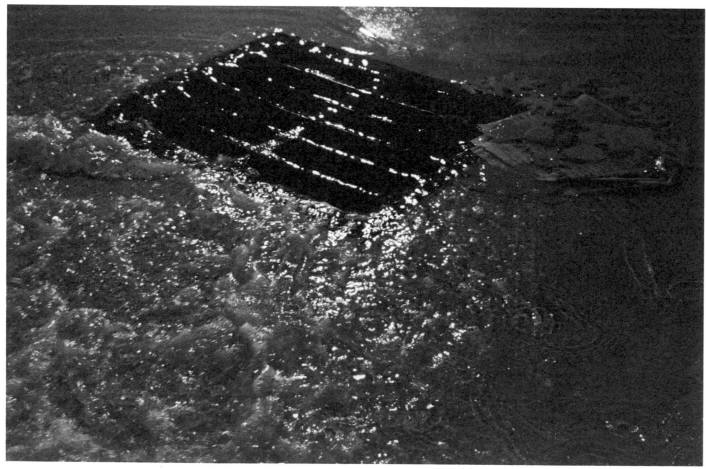

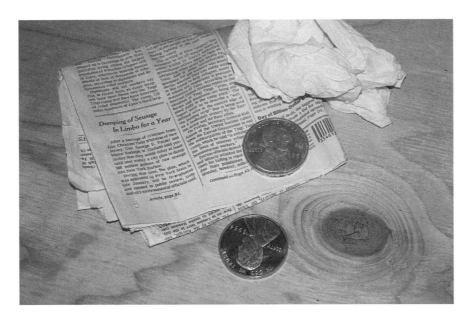

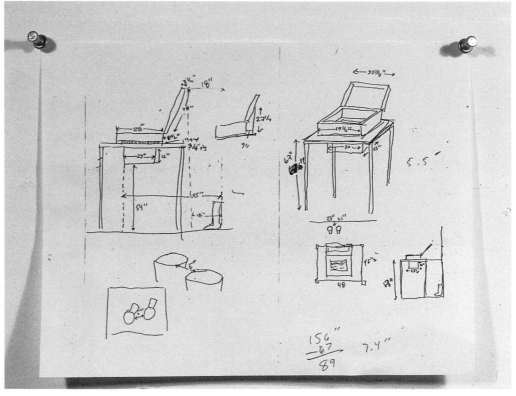

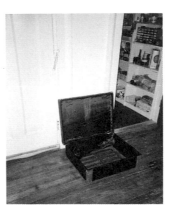
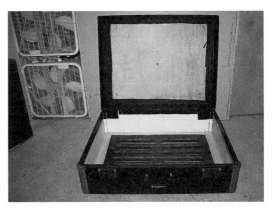

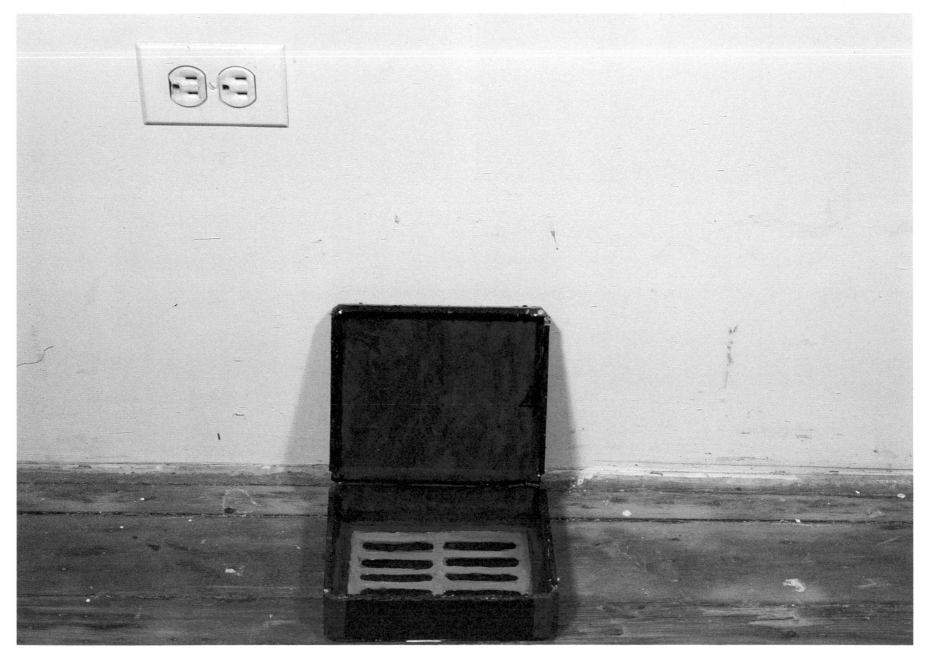

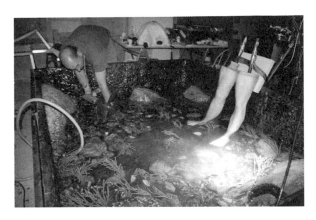

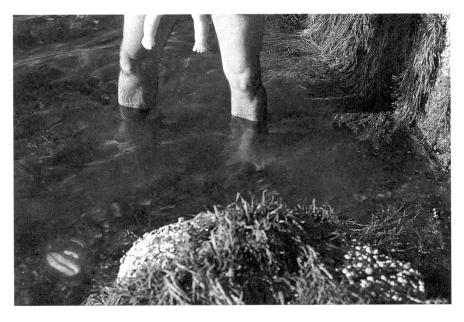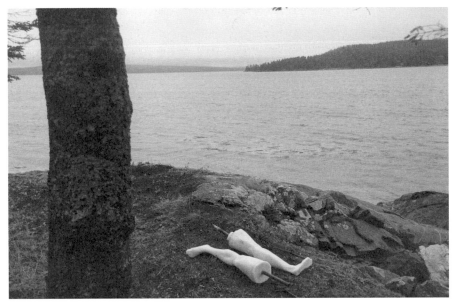

23

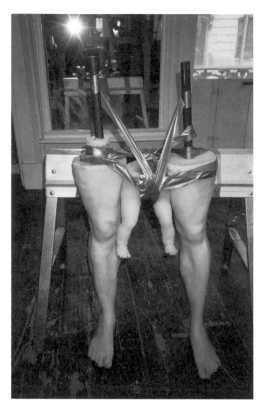

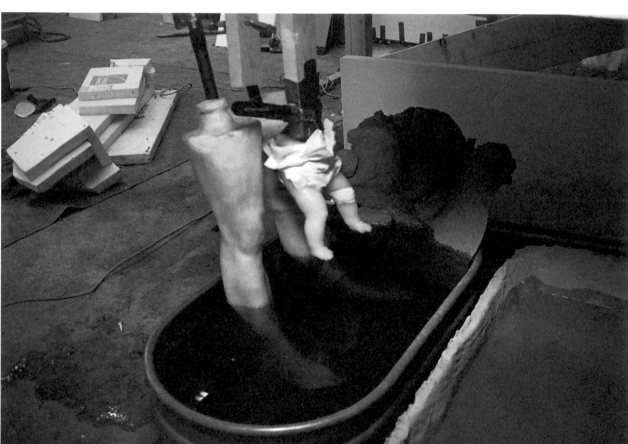

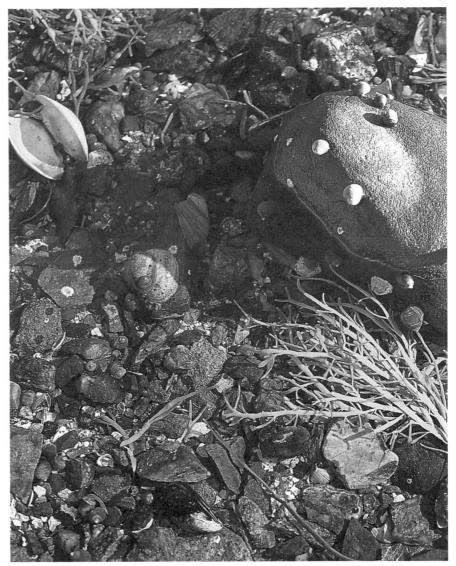

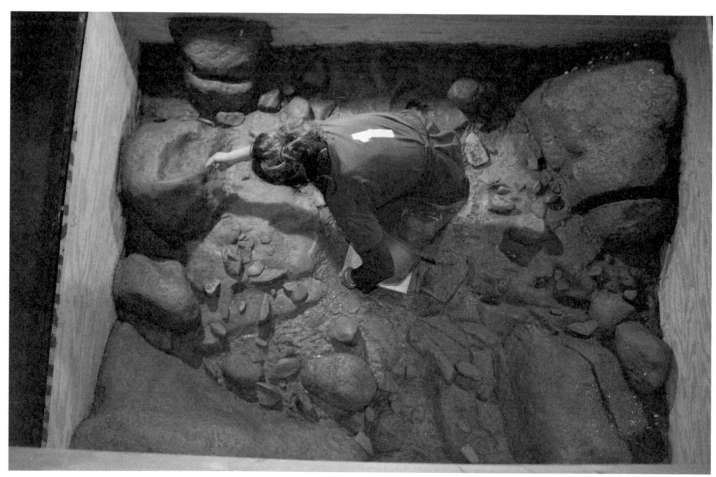

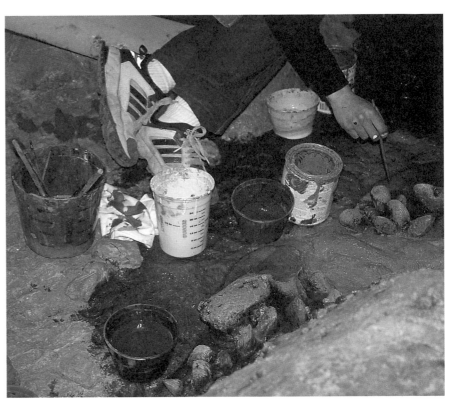

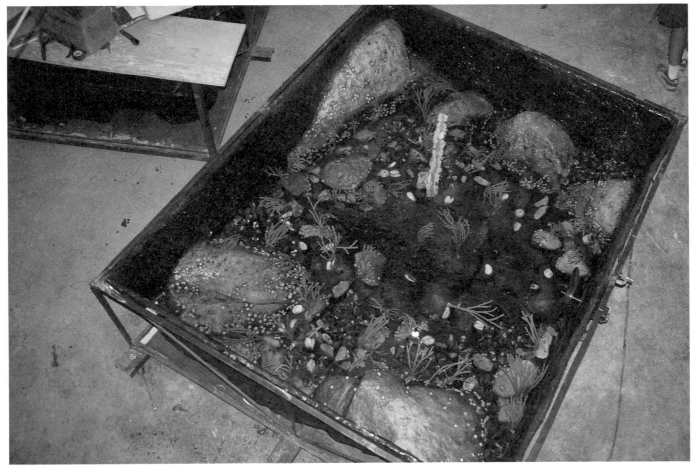

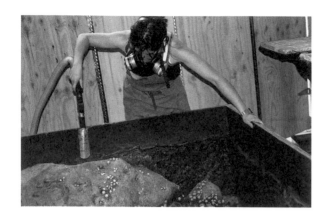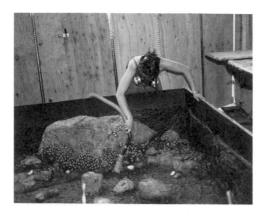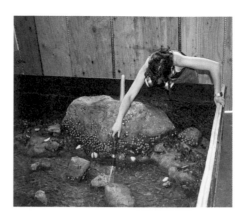

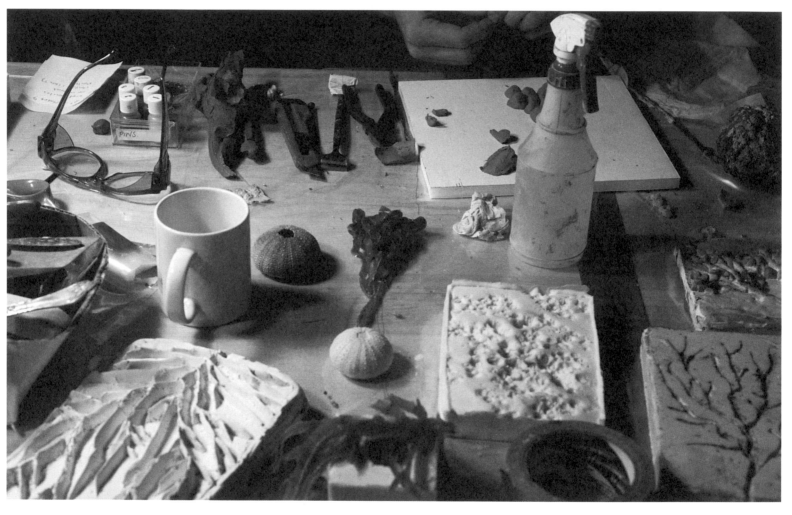

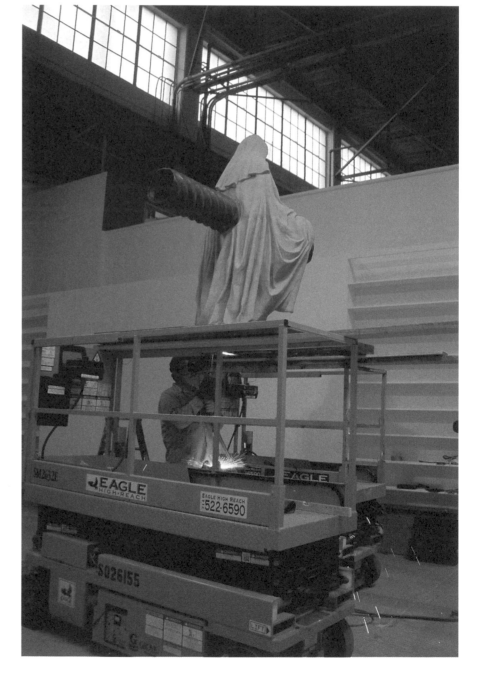

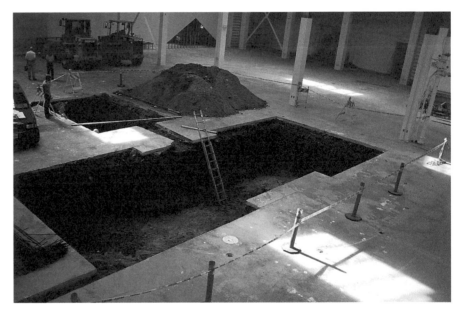

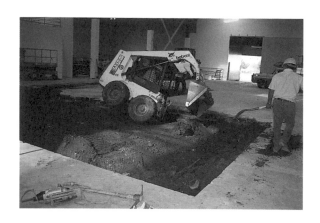

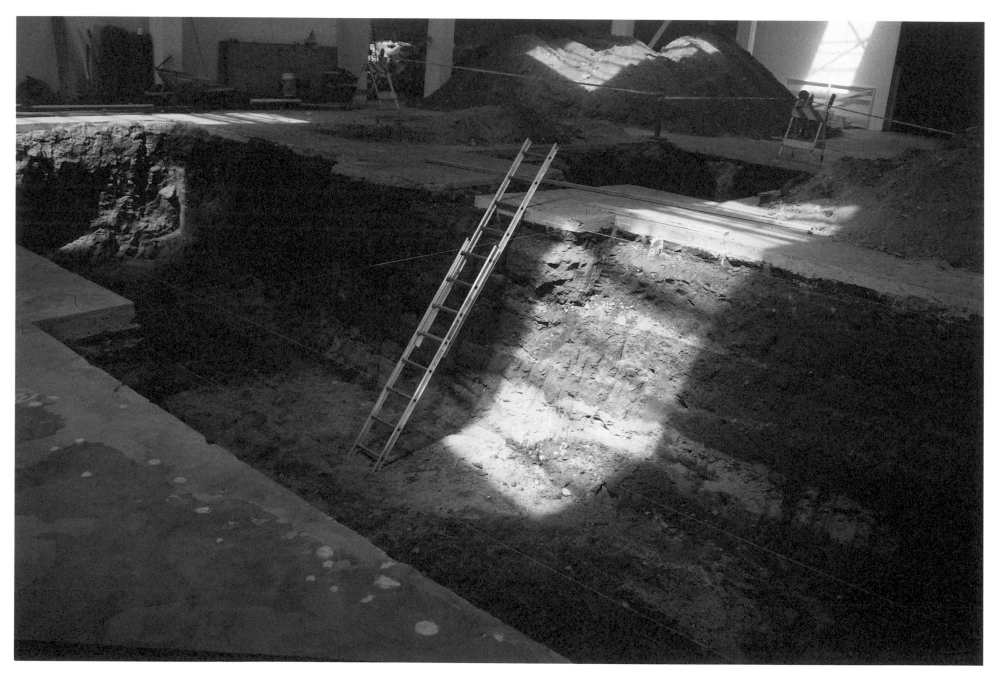

 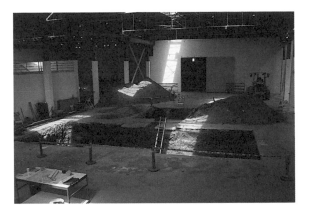 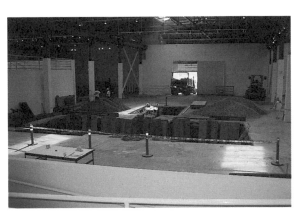

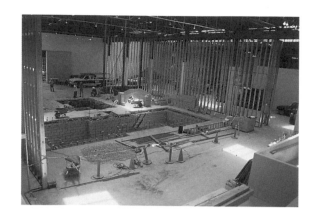

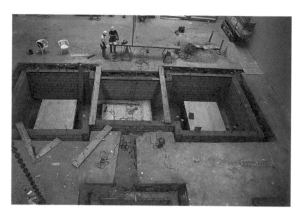

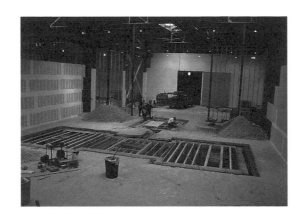

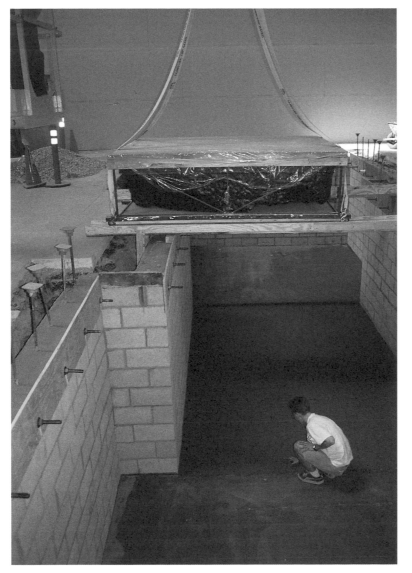

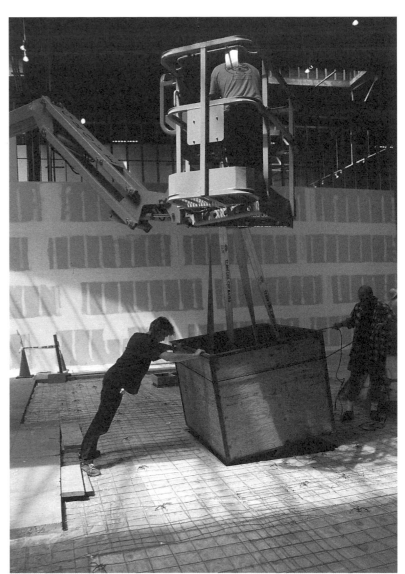

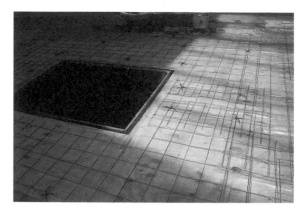

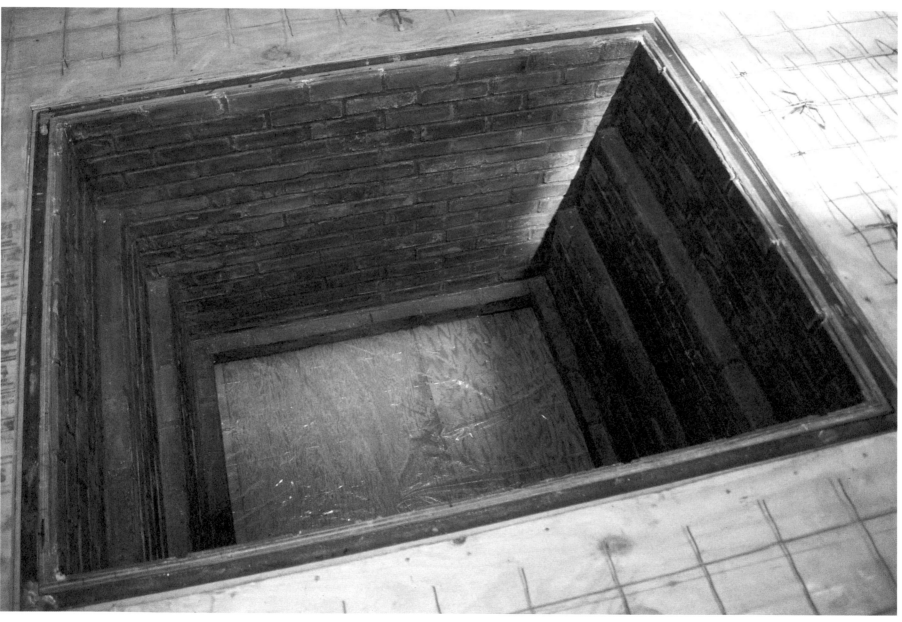

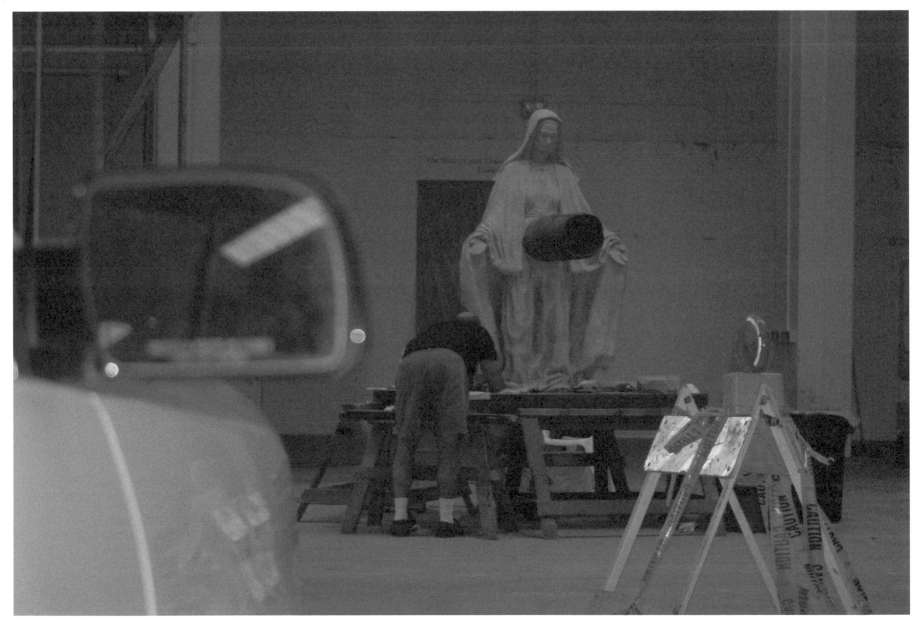

Director's Foreword

Richard Koshalek

Every so often an artist appears whose pervasive effect on those encountering his work—observers and other artists alike—is immediately sensed and unquestioned. This occurrence is so rare that it causes a new, unsuspected awareness of the expressive possibilities of art. The explanation is both simple and complex: for whatever mysterious reasons, these artists are able to fearlessly communicate their personal, emotional state in all its flux and in relationship to the surrounding world as they have experienced it and as it tangibly exists.

Since the early 1980s the work of Robert Gober has consistently accomplished this magical feat. A cigar, a jailhouse window, a running faucet—the most prosaic of objects are transformed by the artist's infinitely subtle manipulation in context into poetic, evocative works of art. With his latest site-specific installation, inspired by the scale and architecture of The Geffen Contemporary at MOCA, Robert Gober has realized his vision at a new level. Composed of four distinct sculptural elements, this work, through its relationship to architecture, evokes both the individual psychic core and the collective, mythic experience.

Many people are responsible for accomplishing this remarkable exhibition at MOCA. Most importantly, of course, we thank Robert Gober for his dedication to the museum and this major project. Nor would the exhibition have been possible without the staunch conviction of its curator, Paul Schimmel, who collaborated with the artist for more than four years. During his eight years as the museum's Chief Curator, Paul has consistently enabled some of the most challenging artists of our time to realize their vision in new and profound ways—yielding such exhibitions as "Helter Skelter: Los Angeles Art in the 1990s," "Sigmar Polke Photoworks: When Pictures Vanish," and numerous provocative explorations of MOCA's permanent collection.

The major support needed to realize "Robert Gober" has also come from a group of individuals whose vision and belief in Gober's work is similarly unwavering. Among them we give particular thanks to Audrey Irmas, Chairman of the museum's Board of Trustees, and The Audrey and Sydney Irmas Charitable Foundation; Lannan Foundation, which through the leadership of J. Patrick Lannan has been an exemplary supporter of contemporary art and artists throughout the world; Ruth and Jake Bloom, with appreciation to Ruth's commitment as a MOCA Trustee; and Douglas S. Cramer, who in his long service as a Trustee has helped see the museum develop as the institution it is today. Thanks are due also for the generous support of Paul Randall and Cormac O'Herlihy and Jon Douglas Company, Malibu.

Acknowledgments
Paul Schimmel

Over the past decade, I've had three opportunities to work closely with Robert Gober, and in each case, the results were unlike what I had imagined they would be. When Gober was first approached about an exhibition at MOCA some five years ago, it was with a retrospective in mind. Since that first inquiry (which Gober declined), his participation at MOCA has evolved from an exhibition in the Isozaki building to one in the Frank Gehry warehouse, and from the construction of a three-dimensional house through which people could walk, to a liturgical tableau, where the greatest focus is on arcadian, subterranean imagery.

With Gober, you may never get what you ask for, and you may end up with more than you had ever hoped. That has been the privilege of working with one of the most single-minded, focused, and dedicated artists of our time in realizing a new work which I believe is one of the most significant site installations in the history of MOCA's warehouse space, The Geffen Contemporary.

I would like to thank Bob for his dedication, and hope that this project meant as much to him as it did to me. For the opportunity to undertake this extraordinary project and for MOCA's dedication to working collaboratively with artists to create new works, several people should be acknowledged. I thank Richard Koshalek, MOCA's Director, who has enthusiastically supported this exhibition from its inception, and more importantly, has created an environment where the impossible becomes conceivable. This exhibition could not have happened without John Bowsher, Exhibitions Production Manager, and his dedication to finding a means to realize artists' visions.

On the staff, I would also like to thank Dawn Setzer, Assistant Director of Communications, Media Relations; Jack Wiant, Chief Financial Officer; Kathleen S. Bartels, Assistant Director; and Erica Clark, Director of Development. Diane Aldrich, my assistant, has worked over the last years to expedite, communicate, and support this project. Russell Ferguson, Editor, has done an exemplary job editing and bringing together a fine team which included Catherine Lorenz, who worked tirelessly to design a book which has the qualities both of a catalogue and an artist's book; Stephanie Emerson, Assistant Editor, for her invaluable assistance in the editing and organization of the publication; and John Farmer, who brought focus and clarity to my essay. Thanks also to Hal Foster, for his insightful contribution to the catalogue, and to Walter Keller of Scalo, with whom we have successfully collaborated on several publications and who understands what is important about working with artists.

From this project's inception, Paula Cooper of the Paula Cooper Gallery has been instrumental in her support. I would also like to thank two members of her staff—Natasha Sigmund and Ona Nowina-Sapinski. I very much would like to acknowledge Max Hetzler, who had the foresight to encourage me to collaborate with Bob in the creation of a new work, long before I had even considered asking Gober for the opportunity to organize a survey.

A special thanks goes to Kippy Stroud at Acadia Summer Art Program in Maine, for it was her invitation to Bob that provided the inspiration for the tide pools. Without her camp, this work may have been forever shrouded in darkness.

For the past several years, Gober's crew has worked tirelessly and with enthusiastic dedication on this project. On behalf of the museum, I would like to thank Claudia Carson, Bonnie Collura, Daphne Fitzpatrick, Lawrence Gleeson, Sam Gordon, Jim Sadek, and Suzanne Wright. I would also like to thank Jennifer Tipton and Brian Haynsworth for their work with the lighting.

Bob has generously donated a print to benefit MOCA, and we are grateful for the enthusiastic support of Sid Felsen and Joni Weyl of Gemini Press who are producing it without cost to the museum.

This exhibition has been fortunate to receive significant funding. Warm thanks go to Douglas S. Cramer for his continuing support, and to Paul Randall and Cormac O'Herlihy of the Jon Douglas Company, Malibu. Additional support came from Ruth and Jake Bloom, significant collectors of Gober's work. The Lannan Foundation has played a critical role in its support of new work, and we are very fortunate to count upon them as good friends of the museum for this project and so many others.

I am deeply appreciative for the significant support of all our funders. However, none is more important than The Audrey and Sydney Irmas Charitable Foundation. Early in the organization of this show, Audrey donated significant support and has continued to fund it throughout the intervening years. Additionally, she acquired two significant works from the artist's Dia exhibition, which she has promised to MOCA. One could ask for no better Trustee.

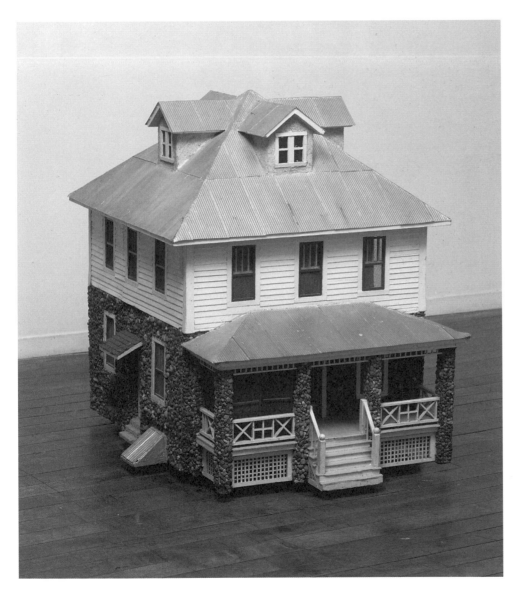

Robert Gober
Untitled, 1979-80

Gober is in the Details

Paul Schimmel

For the past two years, Robert Gober has worked almost exclusively on the conceptualization and execution of a large-scale installation for The Museum of Contemporary Art, Los Angeles. Originally conceived as a house that one could enter, furnished with the artist's signature sculptural objects, it ultimately evolved into a "domestic church." The installation's central component is a life-size figure of the Virgin Mary. Standing in the middle of the installation on top of a sewer grate, she is pierced by a giant culvert pipe. Behind her a torrent of rushing water cascades violently down a staircase into another grate, cast in bronze. To her right and left are two large suitcases, into which grates have also been built. By peering through these grates, viewers may glimpse a pristine subterranean tide pool littered with rocks, sea creatures, pennies, and the enigmatic legs of a man and a diapered baby.

At the museum's invitation in 1993, Gober proposed an installation for the building then known as The Temporary Contemporary and now known as The Geffen Contemporary. The installation was to consist of an entire house. Gober had

43

anticipated creating such a house since the late seventies, when he made a series of dollhouses. Although he originally fabricated them solely to earn money, separate from his work as an artist, he was so fascinated by what the house symbolized that he eventually began to make houses as sculptural objects. But the house that he intended to build in The Geffen Contemporary was to be the most ambitious construction of his career. It was to consist of three levels, including a basement, with each level approximately thirty feet square. Peering through eroded walls hanging from an open skeletal armature, viewers would have been able to see a staircase, with water flowing down the steps, and numerous sculptural domestic objects.

Ultimately, Gober radically altered his original conception for the installation. As he has stated, he began to feel that the house was "too limiting as a metaphor. I had outgrown needing to find everything within that. I had outgrown the need to only look there for material, for solutions, for memories."[1] He became increasingly interested in exploring religious imagery in more depth. The house evolved into the domestic church. To complete the installation, Gober devoted an additional year beyond the period that he had initially allocated for the project and moved from his studio, a parlor floor in a brownstone, to a more industrial space in which he could construct the entire installation.

Gober was raised a Catholic. Although he did not attend Catholic schools, he did attend catechism class on Saturdays and was baptized and confirmed; he also served as an altar boy. Like many young Catholics, he was deeply inspired by the theatricality of the religious tradition he inherited. He especially appreciated what he has termed its "rich body-bound imagery, from the ecstasy to the suffering."[2] In fact, the drama of such imagery became as compelling for him as the drama of military games are for other children.

But as an adolescent, Gober began to realize that his homosexuality was irreconcilable with traditional church doctrine. Dave Hickey has lucidly commented on Gober's

ensuing spiritual conflict and the influence that it would have on his work: "There is a more profound disaffection that flows beneath the surface of Robert Gober's work—a darker music— and for its sources, I think we must look back to the child that Gober describes himself as having been: the homosexual son of Catholic working people, the infant blessed and damned in the earliest memory with an awareness that his 'nature' is at odds with the 'nature' of the culture in which he lives."[3] Gober himself has stated that the church was "telling me that I was bad for being what I was and that there was no way to live as this person, so it was a great struggle to distance myself from something that I was so involved in." Indeed, the church was the "ultimate moral authority," Gober has insisted, "from which a lot of social mores emanated; it was part of a broader confederation of institutions that included the law, newspapers, criminality, family and even folklore." His efforts to understand his position with respect to these institutions—and especially with respect to the church, which he concluded was as "sick and hypocritical" as it had judged him to be—produced a dark sense of confusion.

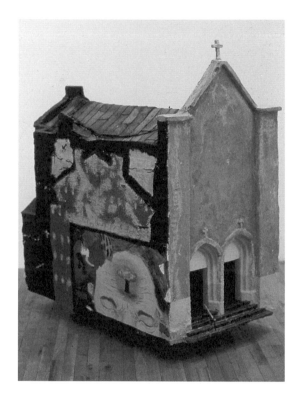

Robert Gober
Prayers Are Answered, 1980-81

As an artist, Gober chose not to ignore the church. Instead, he cannibalized, reconstituted, and regurgitated the moral system that was at such odds with who he was, yet so inspirational for who he was to become. He created a spiritual reality that did not exist within the church but in the glories and healing of nature. He reconstructed a nature to which he could look for redemption from his complex, conflicted, and thunder-

44

ously agitated vision of his place in Catholicism.

This attempt to rebel against received tradition to discover and define his own voice has been evident from the beginning in Gober's work, which has become more and more personalized. One of his earliest works is *Prayers Are Answered* (1980-81), a model of an eroding biomorphic urban church decorated with a painted mural. It anticipated the seminal *Slides of a Changing Painting* (1982-83), comprised of scores of

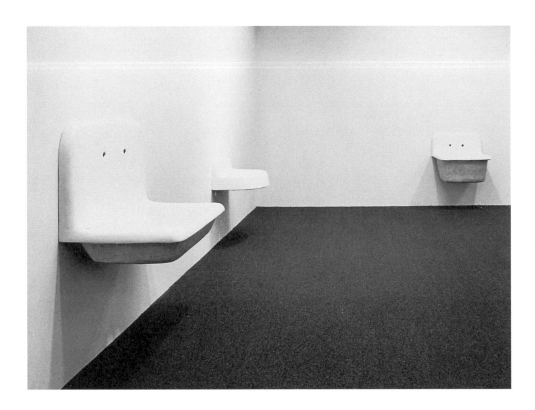

Robert Gober
Sinks, 1985

disturbing images marking the transformation of a man's body, similar to his own. Gober later produced a series of sculptures of sinks, urinals, door frames, and wall panels that also resonate with personal meaning. But it was with the solo installations he began to produce in the late eighties that he developed his most deeply personalized matrices of autobiographical references that simultaneously intersected with social, political, and cultural issues.

With his installation for The Museum of Contemporary Art, Gober has returned with emphatic clarity and relentless

compassion to the subject of the church after a lapse of many years.

Standing in the center of the installation, both literally and symbolically, is the figure of the Virgin Mary, who has a unique position within the Catholic church. She is simultaneously human and divine—a mortal woman and the Queen of Heaven. She experienced intense suffering: fleeing from a murderous ruler, she became a refugee in a strange land and gave birth while homeless; most tragically, she witnessed the unjust execution of her own son. Yet, in her infinite mercy, she intercedes with Christ on behalf of sinful humanity.

It is not coincidental that Gober chose a culvert, a pipe typically used to divert naturally flowing streams beneath roadways, as the instrument of the Virgin Mary's transformation. Her womb penetrated by the giant pipe, Gober's Virgin Mary stands with her arms at her sides and her palms facing forward, simultaneously ready to receive viewers and to keep them at "culvert reach." One of the last elements to be introduced into the installation, this figure ultimately provided the critical formal and conceptual unity that Gober had sought from the beginning. Peering through the void of the culvert where her womb once was, viewers see water cascading down a staircase behind her. By "filling" the void with water violently descending an ordinary staircase from an ordinary home, Gober tied his original domestic conception to an inquiry into the mystery of birth and growth, not just of the physical body, but of the self. Yet Gober's sterile Virgin Mary stands in stark contrast to the one who has been called "the aqueduct along which divine grace flows to the earth."[4]

Gober had considered several options for the treatment of the center of the installation. He even contemplated leaving it empty. However, he soon decided to experiment with placing a changing repertoire of objects in this central space. These included a giant dog bed modeled on a previous work, in which he had painted controversial images of a sleeping white man and a hanged black man on the bed's pillow.[5] Underscoring the

surrealistic quality of his vision, at one point Gober thought of enlarging the bed to make a huge basket that would occupy the space in a manner similar to the image of the giant green apple in René Magritte's *La chambre d'écoute* (The Listening Room, 1952). After he abandoned this idea, he considered placing a gigantic torso under the sewer grate in the center of the installation in the basement of the house.

While Gober had explored Catholic themes in previous works, his decision to incorporate a religious figure represented a dramatic departure for him. Modern artists had largely ignored overtly religious subjects, and Gober himself had only engaged such iconography in a cursory manner. He proceeded to shop for various religious figures, including a crucifixion and the Virgin Mary, and he ultimately settled upon the latter, even though at one point he had planned to reserve it for a project completely independent of the present installation.

Throughout his career, Gober has created a multitude of heartless, headless, and wombless female figures; his figures of mothers in particular stand in stark contrast to the stereotypical image of mothers as paragons of wholesome goodness in the tradition of the Virgin Mary. These sinister mothers are especially prevalent in Gober's newspaper prints, which he exhibited in bundles in his installation at the Dia Center for the Arts in New York City in 1992-93. These works are prints virtually indistinguishable in appearance from actual newspapers with articles taken directly from periodicals like *The New York Times*. One article is especially disturbing. It states: "Youth Worker Held in the Death of Son, 9. Woodbury, New Jersey, May 10. AP— a state youth worker has been charged with murder in the death of her 9-year-old adopted son, the authorities said. She was accused of beating him with a 10-inch piece of broomstick. The woman had been held in Gloucester County Jail since she took the child early Thursday morning. Mrs. Prince of Monroe Township told the authorities that she was punishing the boy, who was adopted when he was three. The boy was airlifted to Children's Hospital in Philadelphia where he died." Another

article, (this one fabricated by the artist), in which a mother is implicated in the drowning of her son in the family's pool, is equally disturbing; this child was six years old in 1960, when he died, making him Gober's age. These darkly perverse stories recall those told by Gober's own mother. As he has stated, "My mother, before she had children, used to work as a nurse in an operating room, and she used to entertain us kids by telling stories about the hospital. One of the first operations was an

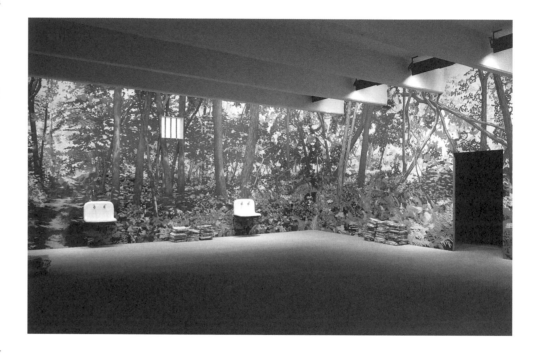

amputation and they cut off the leg and handed it to her. Stories like that made a big impact."[6]

The perverse personalization of Gober's work is especially evident in his figure of the Virgin Mary. He wanted the figure to be life-size, and he also wanted to model it himself, which he did with the assistance of his staff.[7] For Gober, modeling clay is like the "wet earth," and he desired to shape this material into the Virgin Mary's body with his own hands. As he has declared in shockingly visceral language, "I wanted to get my hands in her and make her, remake her." One thinks not only of the sexual implications of this phrase, but also of the declaration in Genesis that God created Adam from clay and

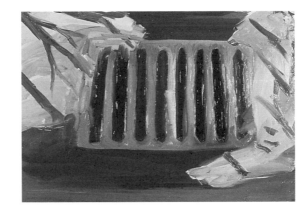

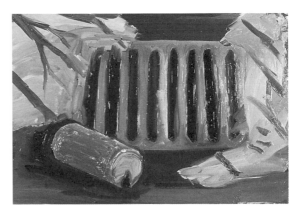

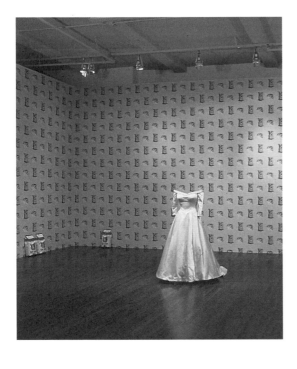

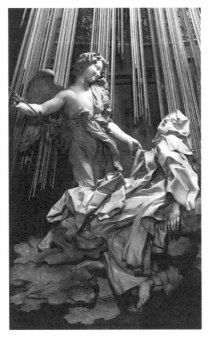

Robert Gober
Slides of a Changing Painting,
1982-83

Robert Gober
*Wedding Gown, Cat Litter,
Sleeping Man/Hanging Man
Wallpaper*, 1989
Paula Cooper Gallery,
New York, 1989

Gian Lorenzo Bernini
Ecstasy of Saint Teresa
(1645-52)
Santa Maria della Vittoria,
Rome

Eve from Adam's rib.

Just as Gober's role in the making of the figure ensured that it would be a physical extension of himself, so did its appearance. Both the figure and the culvert pipe that penetrates it are Gober's height—six feet (minus one inch because of shrinkage). This process links the figure to the centerpiece of Gober's first major installation at Paula Cooper Gallery in New York City: the *Wedding Gown* (1989), a bridal gown for which he was also the model. He even photographed himself wearing this dress in his newspaper prints, in which it accompanied an article about the exclusion of same-sex couples from the institution of marriage.

From the original clay model, Gober then cast the figure in concrete, which he subsequently sandblasted to soften its hardness, making the figure appear weathered, but also ghost-like. Like many artists of his generation, Gober was trained largely in the conceptual aspects of art. Producing a figurative sculpture in a durable medium is a genre that has had little currency within the avant-garde since World War II. In fact, only recently have serious artists, notably Katharina Fritsch, Charles Ray, and Kiki Smith, begun to return to figurative sculpture. These artists have coincidentally aspired toward a type of craftsmanship to which Gober has also aspired, in contrast to the slickness of industrially fabricated sculptures. In some respects, Gober's figure of the Virgin Mary can also be linked with the work of the last significant modernist sculptor who focused upon the human figure—Henry Moore. In particular, the hole through the figure's body is reminiscent of the negative spaces that pierce Moore's biomorphic wooden and bronze sculptures, even though its meaning is entirely different, owing more perhaps to the drains which have been a recurring motif for the artist.

After initially sculpting the Virgin in clay, Gober used a female model to give the figure the attributes of a real woman. He then draped her in a robe made of plaster, suggesting Bernini's *Ecstasy of Saint Teresa* (1645-52), in the church of Santa Maria della Vittoria in Rome. In this sculpture representing the ecstatic vision of Saint Teresa of Avila, an angel has pierced her heart, leaving her utterly consumed by the great love of God in

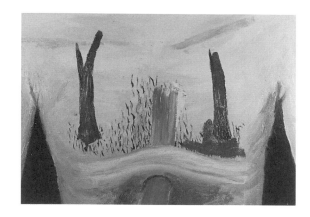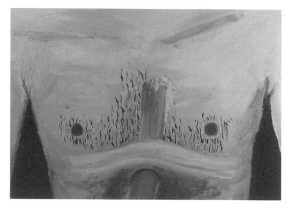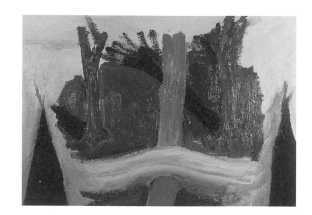

a rapture of pleasure and pain. The deeply modeled folds of the robes of Gober's Virgin Mary evoke the deeply carved folds of Bernini's Saint Teresa and permit an equally dramatic play of light and dark. However, the facial expression of Gober's Virgin Mary is more serene, even severe.

Just as Bernini pierced his figure of Saint Teresa with a phallic arrow, Gober pierced his Virgin Mary with a phallic culvert pipe. Referencing the original sin, this "phallus" is nonetheless womblike in its hollowness. Gober initially experimented with penetrating a model of the figure with a cannon. But while working with this model, he began to realize that he had been drawn to the cannon primarily because of its shape—the same shape as the culvert pipes that penetrate a variety of objects in several of his previous sculptural works.

There are many precedents for this image of bloodless penetration in Gober's oeuvre. In *Man Coming Out of Woman* (1994), Gober represented a breech birth, in which Gober's adult, hairy leg, dressed in trouser and shoe, emerges full-size and newborn from a woman's vagina. The motif of the culvert pipe first appeared in *Slides of a Changing Painting*. In one scene from this work, the pipe diverts a stream beneath a path through a wooded glade projected onto a man's chest; in another, the pipe protrudes directly from his chest. Other scenes depict permutations of these images. Gober had considered creating a three-dimensional pipe since the late eighties, but had never been able to figure out how to make one sculpturally interesting. However, after he produced *Cigar* in 1990, he

realized that he was creating a pipe in shape and scale that, with modifications, could stand alone, like *The Wedding Dress*. Finally, more than ten years after *Slides of a Changing Painting*, Gober created a group of three sculptures pierced by pipes—*Chair with Pipe, Tissue Box*, and *Lard Box* (all 1994-95).

Both the cannon and the culvert pipe have rich sexual connotations. They are phallic-shaped objects with hollow interiors; in addition, they evoke ejaculation: the cannon shoots and water flows through the culvert. For these reasons, penetrating the Virgin Mary with a culvert had a thoroughly different resonance than penetrating an armchair, tissue box, or lard box. Yet, Gober's decision to abandon the cannon represented a tempering of what could have been an exceptionally violent image. On the contrary, he inserted the culvert into the Virgin Mary as if it were an organic part of her body, with which it fused. Indeed, it is almost womblike in its hollowness. The fact that the corrugated pipe's screwlike ribs penetrate the body bloodlessly evokes the Immaculate Conception by which the Virgin Mary

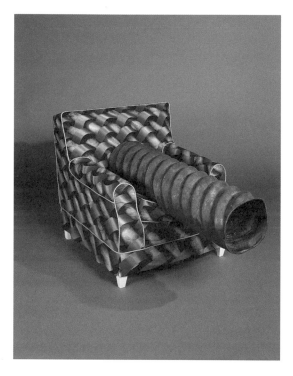

Robert Gober
Slides of a Changing Painting, 1982-83

Robert Gober
Chair with Pipe, 1994-95

was conceived in her mother's womb without the violent stain of original sin, as well as the miraculous conception of Christ himself. Yet the culvert deprives the Virgin Mary of the womb from which Christ was born.

The hole in the figure also evokes statues of the *vièrge ouvrante*, produced in Europe in the fourteenth and fifteenth centuries as objects of devotion; in these works, the open belly of the Virgin Mary reveals the Holy Trinity. In Gober's figure, it

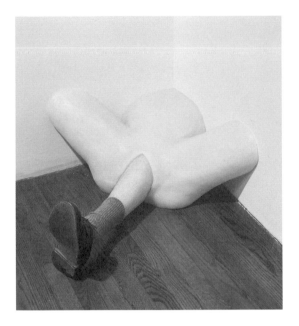
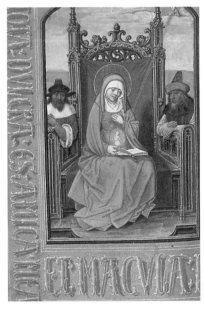

Robert Gober
Man Coming Out of Woman,
1992

Attributed to the Master of
the Grimani Breviary
*Hours of the Virgin,
Bruges*, c. 1515
The Pierpont Morgan Library,
New York

reveals the water cascading down the staircase into the tide pool, creating a complex chain of metaphorical associations. Catholics have traditionally conceived the Virgin Mary as pristine, a purity manifested through the seamless wholeness of her body. She is a "closed gate," a "spring shut up," a "fountain sealed." By contrast, Gober's Virgin Mary is opened up by a phallic object linked visually to the implied violence of the onrushing water—a substance that is nevertheless cleansing, purifying, and life-cleansing. Baptismal. Jesus Christ himself has often been referred to as a fountain of life, of salvation, and water is said to have gushed from him on the cross when a Roman soldier pierced his side with a spear. Gober combines the idea of Jesus as a fountain; the staircase as a reference to

Jacob's ladder that links God and man; and the sacrament of baptism, but transforms them through his manipulation of the iconic images. The foundation of life becomes a raging torrent that prevents any ascent of the staircase.[8] Instead, it faces one down towards what at first appears to be a sewer. The apparently hellish sewer, however, turns out to be a kind of natural paradise.

In a surrealistic manner, Gober has thus brought together conflicting elements in a way that can not be explained rationally, except as a dreamlike phantom of the mind. He has long perceived the world in terms of binary oppositions, such as positive/negative, male/female, left/right, up/down, and light/dark. Indeed, many of his works, including the present installation, manifest an oppositional structure. One thinks of his splitting of houses (as in his early models), of his more recent splitting in half of a wall at the Museum für Gegenwartskunst in Basel in 1995, and of sculptures such as *The Wedding Gown* and an untitled sculpture of 1990 consisting of a grotesque torso that is half-male and half-female. In his figure of the Virgin Mary, the two halves of humanity, man and woman, merge together; he has described this union of opposites in the following terms: "the things grew as one, as if nature has been altered in such a way that the two could accommodate each other. Not as if two separate elements were forced together, but instead as separate and opposite elements that grew as one."

The centerpiece of the house that Gober had originally intended to build in The Geffen Contemporary was to be a staircase with water running down the steps. This staircase was based upon an image that he had represented in *Slides of a Changing Painting*. The building's verticality, as well as the opportunity to penetrate the floor, convinced him that he could finally realize this vision in three dimensions. Even though the house ultimately metamorphosed into the church, the staircase remained an essential component of the installation.

More than the other components, the staircase refers

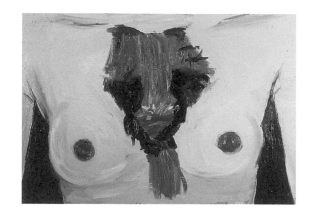

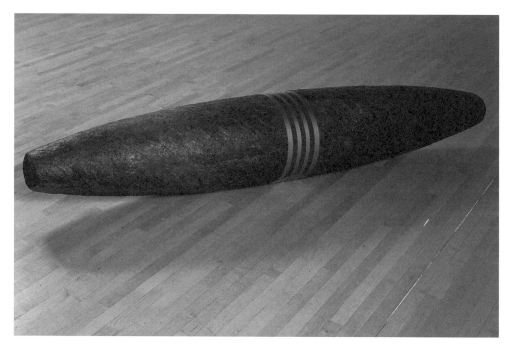

most directly to the domestic constructions that have dominated Gober's non-figurative works. From the early dollhouses to the later door frames, beds, cribs, and sinks, Gober has continually been drawn to the house and its furnishings. For Gober, the house is a metaphor for the body. In his works, as Nancy Spector has written, "The house and its furnishings become analogues for the human body. One is reminded of Freud's conviction that dream images of the house and its attributes—specific rooms, *staircases*, windows and doors—represent, in highly veiled form, libidinal desires of an individual body."[9]

As a structure that bridges different realms, the staircase has a specific symbolic meaning for Gober. It is a "nonspace" through which one moves physically from one place to another; for Gober, it is also a nonspace through which one moves psychically. It connects the upstairs with the downstairs and heaven with hell. Traditionally, upstairs is where one sleeps, dreams, has sex—a space of rejuvenation; by contrast, the downstairs of the basement is decidedly more ominous. However, in Gober's installation, the connotations of upstairs and downstairs are reversed. His staircase leads up to a dark, forbidding space from which pours a flood, as if a calamity of biblical proportions has struck. While the sound of the water in Gober's installation at the Dia Center for the Arts mimicked a babbling brook, the sound of the torrent in the present installation is as anxiety-provoking as the sight of the figure of the Virgin Mary penetrated by a pipe. Yet this same water splashes

down into an Arcadian tide pool illuminated with heavenly light. The life-generating forces of the bedroom have been transferred to the basement. In this regard, Gober has reversed not only the traditional connotations of upstairs and downstairs, but also the traditional locations of heaven and hell.

Since his childhood, Gober has been fascinated with water. He remembers going to the beach, splashing sea water into different shapes in the air, and thinking of how he could form the ephemeral splashes into permanent sculptures. These vivid, pleasurable memories seem often to be at odds with the water one sees in his paintings and installations. For *Slides of a Changing Painting*, he created images of water flowing out of a

Robert Gober
Slides of a Changing Painting,
1982-83

Robert Gober
Cigar, 1991

Robert Gober
Slides of a Changing Painting,
1982-83

Robert Gober
Split Wall with Drains,
1994-95

Robert Gober
Drain, 1989

man's body through a pipe inserted into his chest. For his installation at Dia, he provided his enigmatic sinks at last with real running water. For his installation at the Museum für Gegenwartskunst, he sank drains into the floor on either side of a split wall; at the bottom of these drains were layers of leaves and a crumpled beer can, as well as an envelope that moved with the onrush of the water. For the present installation, water has the most disturbing, even nightmarish, quality, for nature has overrun a domestic architectural space, threatening it with destruction. Yet the piece is hopeful. Gober's realization of his childhood wish to make a sculpture of water, as he has done, manifests a dual sense of anxiety and solace.

At one point in his conception of the installation, Gober considered covering the entire floor of The Geffen Contemporary with floor boards to create a passageway into the house he had planned to construct. However, he ultimately decided to recess a grate into the building's cement floor, so that the water would not only flow into, but also around, the grate in a manner consistent with a heavy downpour. He placed this grate, which is made of cast bronze, at the bottom of the staircase. It is the same size as the grates that form the bases of the two suitcases that flank the figure of the Virgin Mary. Through these grates viewers can glimpse the mysteriously illuminated subterranean tide pool.

Gober conceived the idea of creating a tide pool in an urban environment about ten years ago, when he was thinking about public sculpture. As he was walking across Cooper Square in New York City one day, he thought it would be interesting to build a storm drain—before he had begun to use the drain as a central motif in his sculptural work—through which viewers could "see a stream running and grass growing and daylight, but underground in the middle of Manhattan." This imaginary stream eventually became the tide pool beneath the concrete floor of the industrial warehouse exhibition space that is The Geffen Contemporary.

In the summer of 1996, Gober began to envision what this tide pool might look like. As he has stated, "I knew darkness was inappropriate, but I didn't know what was appropriate." In Maine that summer,[10] he became deeply inspired by the over-

whelming beauty and natural splendor of the life-supporting tide pools he visited along the coast. They were "teeming with life from urchins to starfish to seals," he has observed, and "their beauty was encouraging."

With the tide pool, Gober realized a vision of nature in three dimensions that he had only been able to realize in two dimensions in previous works. For an exhibition with Christopher Wool at the 303 Gallery in New York City in 1988, Gober had planned to create a work using an actual tree that would have anticipated his casting of actual rocks for the present installation. That work, however, evolved into a photograph of a woodland scene in which a dress, patterned with one of Wool's stencils, hung from the branches of a tree. For his installation at Dia, Gober created a dioramalike landscape that covered the walls. But for the present installation, he returned twice to the Maine coast, where he hammered metal onto rocks; gathered mussels, urchins, and seaweed; and took hundreds of photographs. He experimented with numerous materials to develop molds that would allow him to cast rocks directly, by testing dozens of different polymers for the casting of the sea creatures, and by working with a great variety of synthetic rubbers to create seaweed that would both stand up and move. Although a great distance separates viewers from the tide pool, Gober nevertheless created an Arcadian environment that would appear real even from up close.

In her essay "Arcadian Elegy," Maureen P. Sherlock observed that Arcadia in the United States has not been conceived as the mountain idyll of shepherds, but as the domesticity of self-sufficient pioneers who cleared fields for agriculture but preserved the natural environment for direct communication with God and nature. As she writes, "The Americans choose two primary methods of personal salvation which correspond to the different religious conceptions of nature that permeate the American temperament: the Calvinist intensification of an authentic experience of the immediate; or the Unitarian constitution of meeting through authenticating and transfor-

mative labor."[11] Although his tide pool is completely artificial, Gober similarly imbued it with presence by rendering his "authentic experience of the immediate" through his own transformative labor.

The lovingly rendered details of the tide pool also include coins that the artist fabricated. Scattered throughout the tide pool are Lincoln pennies and other coins inscribed with his birth year of 1954. Several times larger than life, these coins

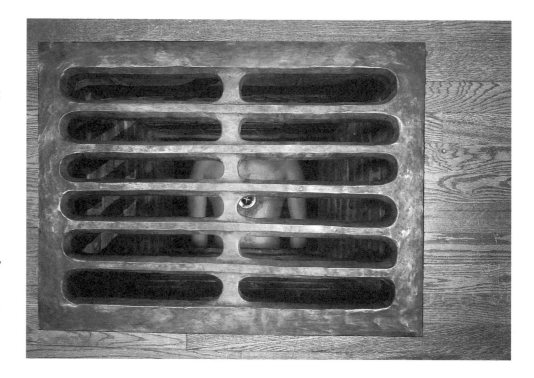

represent a meditation on the meretriciousness of fortune. For Gober, pennies encountered randomly on the street connote hope. They may also refer back to the ritual of passing the collection plate in church; one must pay to pray.

The two suitcases on either side of the Virgin Mary are nostalgic objects reminiscent of those used by middle-class families in the United States during the late forties and fifties. They are similar to the suitcases Gober's mother used when she went away to nursing school—suitcases he remembers always being in the house. Gober himself did not travel until he matriculated at college. He consequently associated suitcases with

Robert Gober
Man in the Drain, 1993-94

his physical and psychological separation from his family and with the process of becoming an adult. Indeed, even though Gober remembers his mother's suitcases most clearly, the somberly colored ones in the installation clearly belong to men. The association of the suitcases with traveling connects these objects with the staircase, a structure that references the experience of traveling both physically and psychically.

Peering through the grates of the suitcases, viewers

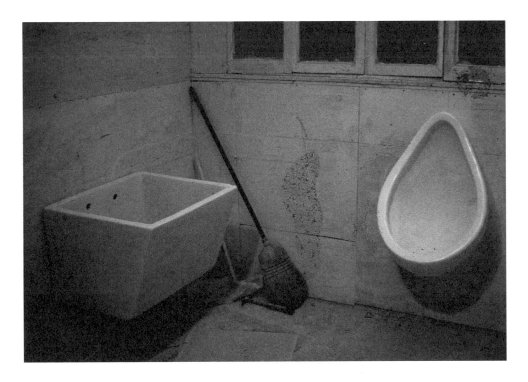

Robert Gober
Broom Sink and *Urinal*, 1984

catch glimpses of the Arcadian tide pool beneath the floor; upon close inspection, one sees the legs of the man and baby. Although looking through the grates is a wondrous experience, it is carefully manipulated by the artist. Indeed, it is difficult to spy the hidden figurative centerpiece and impossible to achieve a full panorama. This manipulation of the viewing experience recalls Marcel Duchamp's famous last work, the *Etant donnés* (1946-66), in which the viewer peers like a voyeur through a peephole onto a diorama revealing the seemingly headless nude torso of a woman in a landscape, her legs spread open to reveal her vagina.

The motif of the fragmented body in water recurs throughout Gober's work. *Slides of a Changing Painting* includes scenes of legs in water. Gober later considered translating these legs into three dimensions by placing them in a white porcelain bathtub, an emblem of cleanliness and purity. This conception evolved into *Man in the Drain*—a male torso lying at the bottom of a well capped by a storm drain, which Gober originally exhibited at Paula Cooper Gallery in 1994. For the present installation, Gober placed fragments of the bodies of a man and a baby in the pristine natural milieu of the tide pool. The fact that the baby is diapered implies that it is in a loving, caring, and nurturing environment—a place of rejuvenation equivalent to the sort of rebirth inaugurated by the sacrament of baptism. It is as if Gober had telescoped his own life in this image of baptismal purification, for he is both the father and the son.

Gober's transformation of the house into a church and the darkness of its basement into a light-filled tide pool was a lengthy and arduous process deeply bound up with his conflicted feelings toward Catholicism—his "home." In spite of the immense intellectual and physical labor that Gober invested in the project, he never researched its iconography by re-reading the scriptures. Instead, he depended upon the memories of his childhood to allow his extraordinarily vivid vision come to pass: the installation is extraordinarily personal.

At the same time, it is boldly public. In 1975 Pope John Paul VI wrote that "At different moments in the church's history and also in the Second Vatican Council, the family has well deserved the beautiful name of 'Domestic Church.'"[12] With the present installation, Gober has made a work of liturgical art that embodies his reformed vision of the church. As surely as the illusion of the security of home was a subject of Gober's original conception of the installation, the security of the church as a spiritual home is questioned and remade in its ultimate realization.

If Gober's childhood in Wallingford, Connecticut in the

fifties did not nurture him, if the political upheavals of the sixties did not include him, and if the sexual revolution of the seventies did not sustain him, in the eighties and nineties he began to remake the world into what he imagined it should be, could be, and as in his worst dreams, sometimes is. As Dave Hickey has written, "Gober appropriates neither norms nor forms from the straight world, but *replaces* them, literally constructs them *all*—the sinks, the plywood sheets, the newspapers, bringing nothing 'readymade' across the abyss of difference. Reincarnating these artifacts as extensions of his own true nature, he colonizes the straight world with them—so that, finally, if nothing else in the world of false facture confirms Gober's presence in it, these objects do."[13] In Gober's antipodean world, up is down, down is up, light is dark, and dark is light; good and evil, father and son, mother and father, are all remixed. It is an alternative world that lies "through the looking glass," in which the promise of hope and birth emerge from its lowest part. If God is in the details of the world he created, Gober is in the details of his.

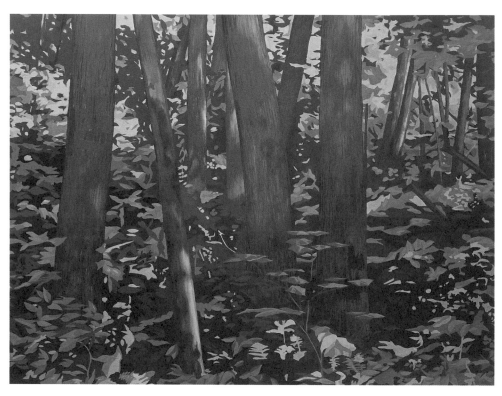

Robert Gober
Slides of a Changing Painting,
1982-83

Robert Gober
Installation at Dia Center for
the Arts, New York (detail)
1992-93

Notes

1. Interview with the artist. Unless otherwise indicated, further quotations from the artist are from this interview.

2. Joan Simon, "Robert Gober and the Extra Ordinary," in *Robert Gober*, exh. cat. (Paris: Jeu de Paume, 1991), 78-84.

3. Dave Hickey, "In the Dancehall of the Dead," in *Robert Gober*, exh. cat. (New York: Dia Center for the Arts, 1992), 37.

4. Richard P. McBrien, ed. *The HarperCollins Encyclopedia of Catholicism* (San Francisco: HarperCollins Publishers, 1995), 34.

5. In the past Gober has experienced the fallout from his politically charged subjects. Particularly controversial was the image of the hanging man/sleeping man, first displayed in the dog bed work, that Gober created for the Hirshhorn Museum's exhibition after having presented it without great incident at Paula Cooper Gallery in New York and the Newport Harbor Art Museum in California. This work angered members of the museum's primarily African-American security staff. When asked if he would ever address racism again, Gober replied, "I don't know. I still feel like I have a right to that imagery. I feel almost indignant that it's my history too; that I inherited this relationship, too, and I can talk about it," in "Hanging Man—Sleeping Man: A Conversation Between Teresia Bush, Robert Gober, and Neil Rifkin," *Parkett*, no. 27 (March 1991): 93.

6. Robert Gober, in Gary Indiana, "Success: Robert Gober," *Interview* (May 1990): 72.

7. Suzanne Wright, working with Gober, did the majority of modeling with clay.

8. My thanks to John Alan Farmer for this point.

9. Nancy Spector, "Robert Gober: Homeward Bound/Auf der Heimreise," *Parkett*, no. 27 (March 1991): 82.

10. Gober was in Maine at the invitation of Kippy Stroud's Acadia Summer Art Program.

11. Maureen P. Sherlock, "Arcadian Elegy," *Arts Magazine* 64, no. 1 (September 1989): 46.

12. McBrien, 517.

13. Hickey, 43.

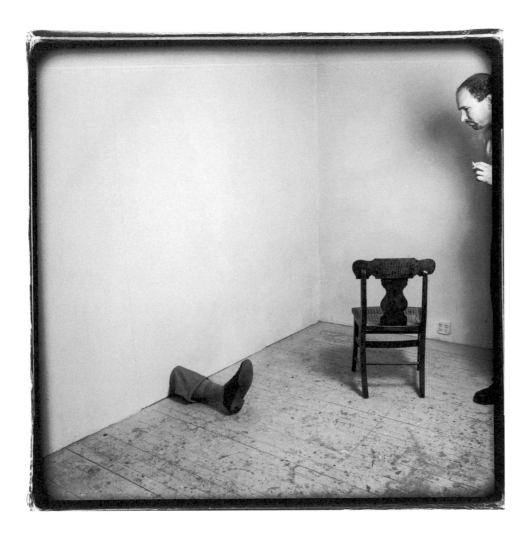

Michael Biondo
Robert Gober, 1991

The Art of the Missing Part

Hal Foster

Two Exhibits

Exhibit A is a black and white photograph. Burned at
the edges, it is difficult to date, and its space is ambiguous — a
spare studio, perhaps a hotel dive. A man stands to the right,
cut by the frame (we see only a head, a hand with a cigarette, a
shoe); a chair is turned to the corner; and a male leg extends
from the left wall. Trousered, shoed, and cut below the knee, it
is inexplicable.

The man peers at the leg. Does he investigate a crime or
revisit a deed of his own, ponder a work of art or hallucinate a
body part? Is he the witness of the event? Its perpetrator? Its
victim? Or is he somehow all three? Clearly the man is a voyeur,
but, if the leg is somehow his, is he not an exhibitionist as well?
To gaze so seems a little sadistic, yet, if this humiliated leg is
somehow his, is he not a little masochistic too? This ambiva-
lence of active and passive roles is performed in visual terms:
both an active seeing and a passive being-seen are in play here,
and they meet in a reflexive seeing oneself.[1]

57

The man is Robert Gober in 1991, and this is the uncanny thing about his art: before it or (more exactly) within it, one has the strange sense of seeing oneself, of revisiting the crime that *is* oneself.

Exhibit B is drawn from an interview in 1990/93. Asked about his way of working, Gober replies: "It's more a nursing of an image that haunts me and letting it sit and breed in my mind, and then, if it's resonant, I'll try to figure out formally, could this be an interesting sculpture to look at?" Questioned about his setting of scenes, he adds: "This seemed a wide open area to me — to do natural history dioramas about contemporary human beings."[2]

These statements are as paradoxical as the photograph. Each object, Gober tells us, begins as an image, perhaps a memory or a fantasy. Yet far from past, it is alive, an infant to be nursed (odd metaphor for an image). However, he implies, it is not yet external: it exists within its host too. Nor is it quite new: it haunts this host as well. Both inside and outside, intimate and alien (a Lacanian critic might call it "extimate"), the image is figured as a brood that breeds on its own. Perhaps it threatens its host; in any case he wants to objectify it, to get it into form — but only if it is "resonant" for others too (the share of the beholder, psychological as well as visual, is large in this work).

To this end Gober sets his objects in "dioramas." Developed in the nineteenth century, the diorama was a scenographic recreation of an historical event or a natural habitat; part painting, part theater, it brought battle scenes to civilians or exotic wilds to industrial metropolises. Closer to peepshows than to pictures, the diorama was loved by the masses but scorned by the cultivated as a vulgar device of *illusion*.[3] Often the tableaux included actual things, but in the service of illusion, an illusion more real than a framed image: a fantasmatic hyperrealism. Gober conjures these effects as well: to make us eyewitnesses to an event (re)constructed after the fact, to place us in an ambiguous space (again, as in a dream, we seem to be within the representation too) that is also an ambiguous time:

"Most of my sculptures have been memories remade, recombined, and filtered through my current experiences."[4] So here the scene of the diorama has changed: neither history nor nature (the first public, the second grand), the backdrop of these memories is at once private and perverse, homey and *unheimlich*.

Primal fantasies

What do the dioramas stage? Whether alone or in an ensemble, the objects often look forlorn: a miniature doll house, laboriously constructed, then burned or split; a wedding gown, laboriously sewn, then stripped of its bride; a cast male leg planted with candles; a cast male butt tattooed with music; and so on. Some suggest a fixated image of an awful accident or a traumatic fantasy, and Gober has alluded to a childhood story, told by his mother (a former nurse), of a leg amputated at a hospital. Yet it is as an enigma that the story struck him, and it is as a riddle that the dioramas resonate. In a sense this is the work of his work: *to sustain enigma*.[5]

Sometimes the dioramas intimate scenes in which the subject is somehow at stake, put into play. Of course, to posit an originary scene in order to ground a self, to found a style, is a familiar trope in modernist art: many movements began with a baptismal name or a foundational manifesto (futurism is only the extreme instance). Art involved in primal fantasies, however, is very different from art staked in origin myths. For primal

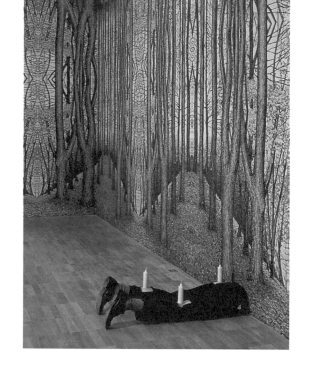

Robert Gober
Untitled, 1991
Background:
Forest Wallpaper, 1991
Installation at the
Jeu de Paume, Paris, 1991

fantasies are *riddles* rather than proclamations of origin: they *confound* rather than found identity. So it is with the Gober scenes as well.

Freud distinguished three primal fantasies in our psychic lives: the primal scene proper (where the child witnesses parental sex), the threat of castration, and the fantasy of seduction. First called scenes, they were later termed fantasies when Freud saw that they need not be historically actual in order to be psychically effective

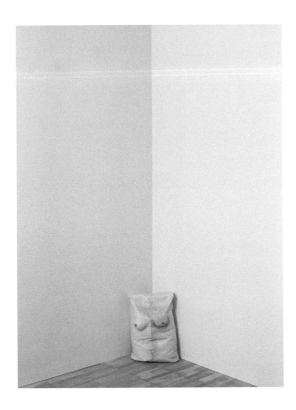

Robert Gober
Untitled, 1991

— indeed, that we often construct them, in whole or part, after the fact (sometimes with the prodding of our analysts). Even when contrived, however, these fantasies appeared consistent, so much so that Freud deemed them phylogenetic inherited schemas that we all elaborate upon. Yet we need not see them as genetic in order to understand them as originary, for, again, it is through such fantasies that the child teases out the riddles of origins: in the primal scene the origin of the individual (where do I come from?), in the fantasy of castration the origin of sexual difference (which sex am I?), in the fantasy of seduction the origin of sexuality (what is this strange stirring within me?).[6]

At first Freud referred each case of hysteria to an actual event: for every hysterical woman in the present there was perverse seducer in the past. Although he abandoned this seduction theory as early as 1897, Freud retained the essential idea of an initiatory trauma. "Presexually sexual" (such is how he struggled to articulate the paradox), the first event comes from *outside* in a way that the child cannot comprehend. It

becomes traumatic only if it is revived by a second event that the now-mature subject associates with the first, which is recoded retroactively, charged as sexual. This is why the memory is the traumatic agent, and why trauma seems to come from *inside* as well.[7] This confusion of inside and outside is the paradoxical structure of trauma; it may be this complication (especially when doubled by a confusion of private and public) that *is* traumatic. In any case Gober (re)stages this complication in the dioramas, with scenes that seem both internal and external, past and present, fantasmatic and real — as though (in a Disneyland designed by David Lynch) we suddenly happened upon the most secret events of our lives.

The primal fantasies are only scenarios, of course, and they never appear pure in life, let alone in art. However, they may help to illuminate this work of "memories remade, recombined" — in particular why its subject positions and spatial constructions are so ambiguous. The scenes of most daydreams are relatively stable because the ego of most daydreamers is relatively centered, and this is true of most pictorial spaces as well: the ego of the artist grounds them for the viewer. This is not the case with the scenes of the primal fantasies, for the subject is implicated in these spaces: put into play *by* them, he or she is also at play *within* them, prone to identify with different elements *of* them. This is so because the fantasy is "not the object of desire, but its setting," its mise-en-scène, in a sense its *diorama*;[8] and this implication of the subject in the space distorts it. Such distortion is also evident in much surrealist art, and more than any other artist today Gober elaborates its aesthetic of convulsive identity and uncanny space.

In his "Manifesto of Surrealism" (1924) André Breton evoked this surrealist aesthetic with a precociously Goberesque image: "a man cut in two by a window."[9] If extrapolated into an aesthetic model, this image suggests neither a descriptive mirror nor a narrative stage, the two dominant paradigms of Western art-making from the Renaissance to modernism, but rather a fantasmatic scene where the subject is split both

positionally, at once inside and outside, and psychically, "cut in two." Two aspects of this model are especially relevant to my reading of Gober. First, in this way of working the artist does not invent forms so much as (s)he retraces tableaux in which the subject is not fixed in relation to identity, difference, and sexuality (again, these are precisely the terms in question in primal fantasies). Second, the location of these scenes is not certain, as is evident in the paradoxical language used to describe them. "It's more a nursing of an image that haunts me," says Gober. "Who am I?" asks Breton at the beginning of his great novel *Nadja* (1928). "If this once I were to rely on a proverb, then perhaps everything would amount to knowing whom I 'haunt'.... Perhaps my life is nothing but an image of this kind; perhaps I am doomed to retrace my steps under the illusion that I am exploring, doomed to try and learn what I should simply recognize, learning a mere fraction of what I have forgotten."[10]

Enigmatic Signifiers

In a series of recent texts the French psychoanalyst Jean Laplanche has rethought *all* the primal fantasies as seductions —not as literal assaults but as "enigmatic signifiers" received from the other (parent, sibling, caretaker), which the infant finds seductive precisely because they are enigmatic. These signifiers, which need not be verbal at all, concern the subject profoundly (again, they involve the fundamental questions of our existence), yet they come from elsewhere, from an other.[11] So, too, the Gober objects seem to arrive from an other, unconscious place, not from the ego of the artist. They possess an *alterity*, and this alterity produces a *passivity* in the viewer, for, again, the objects appear as if suddenly, one feels almost helpless before them, one *suffers* them.[12]

The quintessential enigmatic signifier is the maternal breast, which the infant sees as an entity in its own right. Gober

presents the breast (1990) in this way too — as a part object on its own, a fragment in relief. It recalls *Please Touch* (1947) by Marcel Duchamp, but that breast is more frontal, more aggressive: an object for a post-Oedipal subject, it challenges one to touch, to break the taboo of art,[13] to confuse aesthetic appreciation and sexual desire, to trace the sense of the beautiful to "the secondary sexual characteristics" of the body (as Freud would say). The Gober breast is different: neither good nor bad object (in the terms of Melanie Klein), neither nurturing nor sexual breast (in the terms of Freud), it is exactly enigmatic.

Laplanche ventriloquizes the infant before this enigma in this way: "What does the breast want from me, apart from wanting to suckle me, and, come to that, why does it want to suckle me?"[14] Here the desire of the other prompts the desire of the subject as an enigma, and this enigma recalls the riddle of seduction: What does this other want? What is this strange force that it stirs inside me? What is a sexual object? What is a sexual object

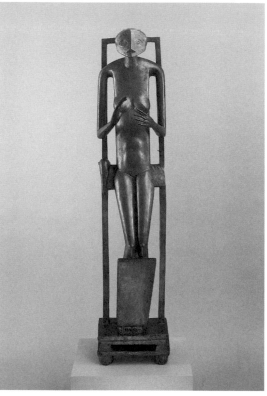

for me? And who — or what — am I? For Freud the sexual drive is "propped" on the self-preservative instinct: the infant at the breast sucks milk out of need, which can be satisfied, but it also experiences pleasure — a desire for the punctual return of this pleasure — which cannot be satisfied. The milk is the object of need; the breast is the object of desire, the first such object for everyone. But even when the constitution of the subject is at issue, Freud tends to presuppose — to project — a heterosexual male. With his ambiguous breast Gober seems to query this

Alberto Giacometti
*Hands Holding the Void
(The Invisible Object)*, 1934
The Saint Louis Art Museum
Purchase: Friends' Fund

60

presupposition, to ask when it can no longer be held. In so doing he implies that the riddle of sexuality cannot be separated from the riddle of sexual difference: across the spectrums of masculine and feminine, heterosexual and homosexual, these two enigmas are bound together.

If the Gober breast poses the riddle of the sexual *object*, his bisex(ct)ed chest (*Untitled*, 1991) embodies the riddle of the sexual *subject*: which gender am I, or, more precisely, what

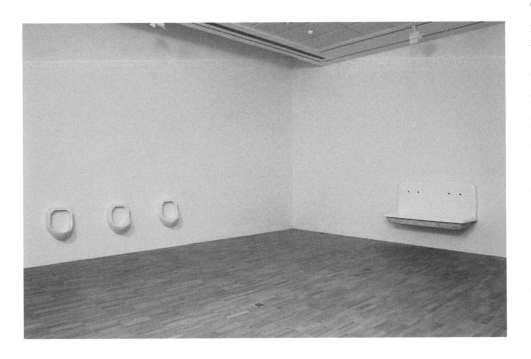

Robert Gober
Three Urinals, 1988
and *Double Sink*, 1984

sexuality? At first glance this hermaphrodite torso seems not so much enigmatic as repulsive — in its very refusal of enigma, perhaps, in its making-literal of bisexuality as double-sex. Nonetheless, the ambiguity of gender persists: the female breast (it is the same one) is a little penile, the male breast a little supple, hair strays into the female side, the male side is fleshy too, and so on. In a sense this truncated torso is enigmatic because it is both literal and ambiguous: here sexual difference is presented as both physically absolute and psychically undecidable. It is irreducibly both, and it is traumatically enigmatic because it is irreducibly both.

The hermaphrodite, then, is not replete: its doubleness reveals a division, its excess a loss, and here Gober allows for a special insight into psychoanalysis and aesthetics alike. For if the breast is our first sexual object, it is also our first lost object. Again, though need can be satisfied, desire cannot be, and in this desire the breast appears lost to the infant. It can hallucinate the breast (in desire begins fantasy and vice versa) or find a substitute (what is the thumb, or the pacifier, but the breast in disguise, in displacement?). On the one hand, then, "the finding of an object is in fact a refinding of it;"[15] on the other hand, this refinding is forever a seeking: the object cannot be regained because it is fantasmatic, and desire cannot be satisfied because it is defined in lack. This is the paradoxical formula of the found object in surrealism as well: a lost object, it is never recovered but forever sought; always a substitute, it drives on its own search. Thus the surrealist object is impossible in a way that the surrealists never quite understood, for they continued to insist on its discovery — on an object *adequate* to desire. The epitome of this misrecognition occurs in the flea-market episode of *L'Amour fou* (1937) when Breton recounts the making of *Hands Holding the Void* (*The Invisible Object*) (1934) by Alberto Giacometti, a sculpture born of a romantic crisis. Breton tells us that Giacometti had trouble with the hands, the head, and, implicitly, the breasts, which he resolved only upon discovery of a mask at the market — a textbook case of an object meeting a desire. But *The Invisible Object* evokes the opposite, the impossibility of the lost object regained: with its cupped hands and blank stare this feminine personage shapes "the invisible object" *in its very absence*. One achievement of Gober is that within a surrealist line of work he reveals the impossibility of its object, the paradox of its aesthetic; he questions the surrealist trust in desire-as-excess with the psychoanalytic truth of desire-in-loss.

Sometimes Gober registers this desire-in-loss less in objects than in settings, as in his "traumatic playpens" (1987). These crazy cribs recall the famous passage in *Beyond the Pleasure Principle* (1920) where Freud discusses the *fort/da*

game of his young grandson. According to Freud, the little boy was devastated by the periodic disappearances of his mother, which he sought to master actively rather than to suffer passively. To this end he represented her movements with a string attached to a spool: into his crib he would throw the spool, make it disappear (*fort!* gone!), only to recover it with the string, to make it reappear, each time with delight (*da!* there!). This game suggests a psychic basis of all representation in loss, which any representation works to compensate a little. However, the traumatic playpens of Gober present a far less redemptive view of symbol-making. Slanted, split, or otherwise deranged, these cribs are cages marked with aggression — whether of the child or the other (as intuited by the child) it is difficult to say. The nastiest playpen is the most normal, as if every pen were potentially a Skinnerian box. (This is true of his beds as well: the nastiest is the most uniform, as if every bed were potentially a straitjacket.) Rather than a happy accession of the infant to representation, then, Gober evokes a blocked socialization. Perhaps the child of these cribs and pens refuses the enigmatic signifier, rejects the name of the father — only, these cages seem to suggest, to earn a name nonetheless, that of psychotic.

From the breast through the torso to the penis, then, Gober asks these questions: What is a sexual object? What is a sexual subject? What is desire? What is loss? (And for whom? Always for whom — even when this *who* is the question.) Moreover, how do we distinguish between subject and object, desire and loss?[16] Even as Gober reveals the found object to be a lost object, he reworks the surrealist aesthetic of desire (often tilted to the heterosexual) into a contemporary art of melancholy and mourning (here tinged gay), in which subject and object may appear confused. This is the problem for the subject struck by loss: as the melancholic refuses to surrender the lost object, he makes it internal, and reproaches it in the guise of a self-reproach, while the mourner learns to relinquish the lost object, to disinvest in this one thing in order to reinvest in other

things, to return to life. Gober captures this vacillation of the forlorn subject between reproach and reverence. On the one hand, the legs planted with candles or plugged with drains may evoke a body consumed or wasted — the body burned at both ends, the body drained. On the other hand, they may also evoke a body radiant or cleansed — the body transformed from an abject thing, too close to the subject, into an honored symbol, distanced enough for the subject to go on with life. Other associations are in play here as well (fire and water, altar and slaughterbench, remembrance and oblivion) in a way that points to an enigma less of origins than of ends — of departures and deaths. What do you do with desire after loss? You burn for a while, carry a torch for a time, eventually light a candle to the memory of the loved one. What do you do with a body after death? You wash it in order to purify it of you and to free you of it.[17]

Gober rejected the Catholicism of his upbringing, but it returns in his objects. Consider his candle seeded with hair (1991): it projects a Catholic sense of the complementarity of the sacred and the profane, of the proximity of the spiritual and the base. Gober complicates this complementarity in his new installation at The Museum of Contemporary Art, Los Angeles. There we descend into a space occupied by a statue of the Virgin flanked by two open suitcases (as always these objects are crafted, not readymade). Behind the Virgin is a stairway. Water cascades down the steps to a drain below which is a bright tidal pool. Underneath the suitcases are more pools, where a man with an infant wades (as usual we see little more than legs). The Virgin stands above a pool too, a wishing well strewn with huge pennies. Like her suitcases (her altarwings?), she seems to be an emblem of passage, the central conduit in this system of flows, the main medium of faith at these different stations of life — life everlasting (the stairway to heaven, the birds in the sky), human in its generations (father and child in the water), and primal marine (the tidal pool). But the message is far from clear, and lest we imagine transcendence, Gober

presents her in worn concrete, a garden ornament eaten away by weather. Indeed, she is run through the middle with an industrial pipe, as if she were only a material culvert in a material world.

In terms of gay and/or Catholic artists, the great precedent for Gober is Andy Warhol, who was also driven to repeat traumatic images, at least in his early work. But both these artists queer a prior figure, and that is Duchamp.[18] However,

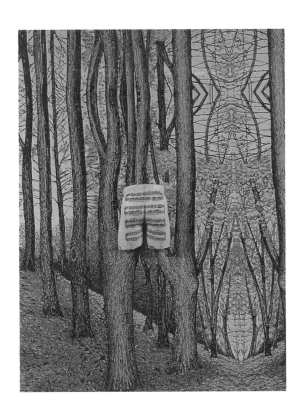

Robert Gober
Untitled, 1991
Background:
Forest Wallpaper, 1991
Installation at the
Jeu de Paume, Paris, 1991

unlike many contemporaries, Gober does not focus on the model of the readymade, which queries the relation between art work and commodity. In fact he almost opposes this model, for Duchamp intends "complete anaesthesia," while Gober explores traumatic shock (again, he seems to look at Duchamp through Warhol).[19] Instead Gober adapts another Duchampian model, the cast body part, which queries the relation between art work and sexual drive.[20] Like Duchamp, he sees cognition as sensual (in the notorious phrase of his predecessor: "to grasp things with the mind the way the penis is grasped by the vagina"), but this cognition is different for Gober because the desires are different. Hence, instead of the "female fig leafs" and "wedges of chastity" of Duchamp, he offers casts of male butts (they may recall the *Torsoes* of Warhol); and instead of the misogynistic fetishes of Giacometti (such as *Disagreeable Object*, 1931), he offers ambivalent relics (like the hairy candle). Nevertheless, the affinity with Duchamp and Giacometti is clear, and it rests in a shared fascination with enigma and desire — with the enigma *of* desire, the desire *in*

enigma. Seduction is also central in Duchamp and Giacometti, but it is seduction as heterosexual quest: the bachelors never attain the bride in *The Large Glass* (1915-23); the banana never touches the peach in *Suspended Ball* (1930-31). There the operative analogy is coitus, but it is coitus not only interrupted but deferred: for Duchamp and Giacometti delay and suspension (privileged terms respectively for each) are fundamental to desire, and this puts them a little awry of the dominant Bretonian line of surrealism. In his bachelor machines Gober queers this formula of blocked desire, revises it in terms of melancholy and mourning, loss and survival — that is, in terms of the age of AIDS. "For me," he remarked in 1991, "death has temporarily overtaken life in New York City."[21]

Human Dioramas

Gober does not focus on the Duchampian readymade, but there are exceptions, such as *Three Urinals* (1988), which recalls the most famous readymade of all, *Fountain* (1917). Yet here too Gober twists Duchamp, literally so, for *Fountain* is a found urinal rotated ninety degrees onto a pedestal, positioned as art, while *Three Urinals* is fabricated and returned to the official place for urinals on the wall. In effect Duchamp brings the bathroom to the museum, with a provocation (beyond scandal) that is both epistemological (what counts as art?) and institutional (who determines it?), while Gober brings the museum to the bathroom (if one urinal signals a public toilet, three confirm it), with an additional provocation: what is it to have an experience usually deemed private — the call of art, the call of nature — in a space usually deemed public?

Although more prosaic than the riddles of the primal fantasies, the mysteries of the bathroom are also more social. We boys forever wonder what is inside the girls room (we imagine a garden of earthly delights and horrors), and we never get over the unease of the boys room as well. To pee is a semi-

private act, but often we do it in a semi-public space where the slash between private and public spheres is the dick in our hand. Straight or gay, we have to wonder about the guys next to us (even when we are alone, our fathers or brothers appear spectrally). Bigger? (Freud got it wrong: penis envy — that is, penis anxiety — is strictly a boy thing.) Better? Vaguely disgusted? Very interested? The Gober urinals call these secret ceremonies to mind, at least to some viewers (the share of the beholder in this work is not only large but specific). They put sexual difference on display in a way that, again, twists Duchamp.

Three Urinals initiated a series of installations with different Duchampian spins. In 1989 Gober did a project at the Paula Cooper Gallery that resonated with *The Large Glass*. In one room he hung wallpaper of dicks and cunts, assholes and belly buttons sketched in white line on black ground and punctuated with drains — as if to suggest that sexual difference is the ambient pattern, both obvious and overlooked, of our everyday lives. In another room he hung wallpaper of schematic drawings of two men in light blue on pale yellow, the one (from a 1950s advertisement) white and asleep, the other (from a 1920s cartoon) black and lynched — as if to suggest that racial antagonism is another occluded structure of our daily existences. Like *The Large Glass*, then, the installation was split into two registers, as was each room: in the center of the first was a bag of doughnuts on a pedestal; in the center of the second stood a wedding gown attended by kitty-litter bags along the wall (all fabricated by Gober and assistants). Thus from space to space, and from images to objects, Gober put a series of oppositions in play: male and female, white and black, immaculate gown and stale food, purity and pollution, dream and reality, and, above all, sexual difference and racial difference.

However, rather than map these oppositions onto one another, Gober intertwined the terms in an ensemble that evoked the intricacies of fear, desire, and pain at work deep in our political imaginary. In a sense this is to elaborate Freud as

well as Duchamp, for here Gober intimates that our traumas of identity and difference are social and historical too.[20] It is also to refunction the diorama as a recreation of an actual event, for here Gober intimates as well that our racist past persists, nightmarishly, in the present. In our political imaginary simple *oppositions* of sex (male and female) and color (white and black) reconfirm one another in a way that makes complex *differences* across sexual and ethnic positions difficult to think,

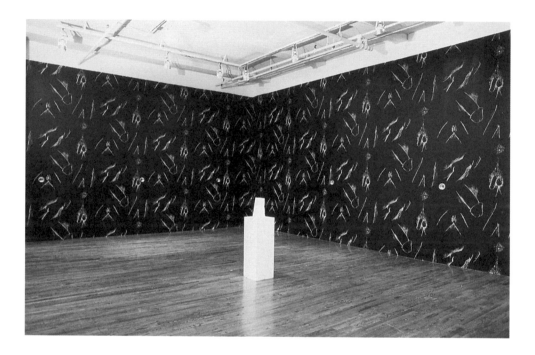

Robert Gober
Male & Female Genital Wallpaper, Bag of Donuts
Paula Cooper Gallery,
New York, 1989

let alone to negotiate. The Cooper installation prompts the viewer to tease out this old American knot in the form of a broken allegory: What is the relationship between the two men? Does the black man haunt the white man? Does the white man dream the black man? If so, does the white man conjure the black man in hatred, guilt, or desire? Is the woman implied by the wedding gown the object of their struggle? If so, is she the pretext of their violence, or the relay of their longing, or both?[23] What is the role of heterosexual fantasy in racial politics? Of racial fantasy in heterosexual politics? And how do homosexuality or homosociality come into play? Finally, how does one *dis*articulate all these terms — clarify them in order to question

them? The installation poses these traumatic questions, only to remain mute. But the wallpaper reminds us that they remain the stuff of everyday realities and every night dreams.[24]

The Cooper installation evokes another work by Duchamp, *Etant donnés* (1946-66). In this diorama the viewer spies, through a peephole in a door and a hole in a wall, a female mannikin spreadeagled in a wooded landscape, with a gas lamp in one hand (the Duchamp version of the Gober candles?) and a waterfall behind her (the Duchamp version of the Gober drains? Influence can flow backwards too). A more literal diorama than the Gober installations, *Etant donnés* is also a more direct recreation of a primal scene, which is presented as a peepshow. But what traumatic origin does one revisit here? The diorama brings into contact two old obsessions of Duchamp, perspectival vision and sexual violation (both are essayed in *The Large Glass* as well). Indeed, prominent theorists have read *Etant donnés* as a making-physical of perspective, one that connects our viewing point, through the holes, to the vanishing point, which coincides here with the vulva of the mannikin. *Con celui qui voit*, Jean-Francois Lyotard remarks concisely of this perspectival structure. "He who sees is a cunt."[25] In this account, then, Duchamp is taken to demonstrate that perspectival vision is not innocent, let alone scientific, that our gaze is marked by sexual difference, by "this

central lack expressed in the phenomenon of castration."[26]

Gober assumes this Duchampian demonstration of the sexual inflection of the visual precisely as a *donné* — as a given to elaborate in other ways. In any case, he played on *Etant donnés* again in a 1993 installation at the Dia Center for the Arts. As in the Duchamp, one confronts a wooded landscape with water, here in the form of wallpaper punctuated with sinks. But the body, the *corpus delicti*, is missing (perhaps we stand in its stead), and our spatial position is also ambiguous: within a room we see a landscape, but this landscape has holes in it — squares cut in the walls — and, more enigmatically, these holes are barred. Bound stacks of *The New York Times* are placed by walls and columns, and a box of rat poison under a sink or two. Both outside and inside, then, we are also somehow below, in a spatial experience that is equal parts Magritte painting, Kafka novel, and apartment building basement. Here the scenic ambiguity of the diorama is exploited not only to complicate the lines of sexual and racial differences and private and public spheres (some newspapers are collaged so as to juxtapose reports of abuse and discrimination with wedding announcements), but also to comment on the divides in American ideology — between the transcendentalist myths of individual and nature (the wallpaper might be called Ever Emerson or Thoroughly Thoreau) and the contemporary realities of mass anonymity and urban confinement. As suggested, the new MOCA installation complicates other oppositions: sky and water, a stairway to heaven above and a sluiceway to somewhere else below, metaphysical transcendence and physical decay.

Marcel Duchamp
*Etant donnés: 1a chute d'eau;
le gaz d'éclairage*, 1946-66
Philadelphia Museum of Art:
Gift of the
Cassandra Foundation

Where's the Rest of Me?

In the end the enigmatic signifiers that affect us most deeply may be "designified," missing in meaning.[27] So it is with the Gober dioramas. "Something's literally missing in the story,"

he says of the Cooper installation, "if you look at it as a story —
and you kind of have to. You have to supply that: what was the
crime, what really happened, what's the relationship between
these two men."[28] Again, this is the work of his work, to sustain
enigma, and it is usually done in two complementary ways. The
first is to evoke a narrative riddle, a story with a hole in it. The
second is to trace the hole somehow, to figure the missing part.
This lost object is not only a desired thing; sometimes it seems
rejected, spited, even accursed: the missing part as *la part
maudite*. It is this quality that can make his objects so paradoxi-
cal and his viewers so ambivalent. Sometimes it is as if one
suddenly beheld the thing that one has sought forever and
dreaded to find. It is this anxious fixation in us that Gober seeks
to fix in his dioramas.[29]

Such insistence on the missing and the *maudite* is
present in dissident art and philosophy of the twentieth century
that challenges the official ideals of aesthetic completion,
symbolic totality, dialectical assimilation, and the like. Subter-
ranean in modernism, which favored Hegelian systems over the
nasty remainders that they cannot absorb, this insistence has
risen to the surface in vanguard culture today. Whether con-
ceived in terms of the heterogeneous (as in Georges Bataille),
the traumatic real (as in Jacques Lacan), the abject (as in Julia
Kristeva), the obscene or the inhuman (which is how I tend to
see it), this motive drives many different aesthetic and theoreti-
cal practices in the present, which faces new totalities of its own
(like cyber virtuality and global capitalism) to resent, perhaps to
resist. It may be premature to venture what this motive means;
perhaps it is misguided as well — that is, if it does want to insist
on the truth of the failed and the force of the enigmatic. But one
thing is clear: Robert Gober is a paradoxical master of this art of
the missing part.

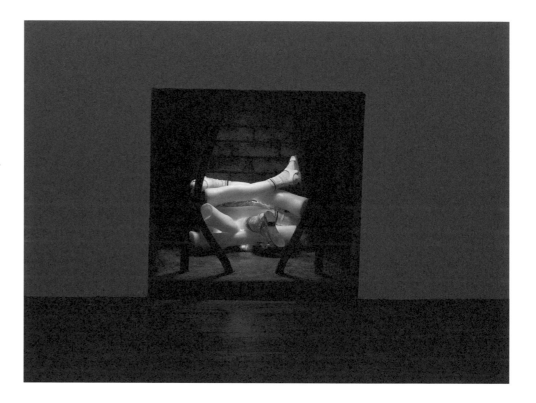

Robert Gober
Untitled, 1994-95

Notes

1. Freud discusses these instinctual doubles and psychic reversals in "Instincts and their Vicissitudes" (1915).

2. Robert Gober, "Interview with Richard Flood," in Lewis Biggs, ed., *Robert Gober* (Liverpool and London: Serpentine and Tate Galleries, 1993), 8-14.

3. See Dolf Sternberger, *Panorama of the Nineteenth Century*, trans. Joachim Neugroschel (New York: Urizen Books, 1977 [1936]). There is hardly a less modernist form than the diorama — that is, less concerned with the exposing of its illusionism or the baring of its device.

4. Gober, "Interview with Richard Flood."

5. I want to register two concerns here. The first has to do with the relation of enigma to interpretation. Enigma is bound up with desire (or so I will argue), and this volatile compound invites an interpretive interest that is also erotic, "epistephilic." It is a Freudian commonplace that our primary investigations are driven by sexual curiosity, and Gober evokes this fundamental riddling in our lives (or, again, so I will argue). The question is how to interpret his riddling so as to explain rather than eradicate it — in a way, moreover, that is neither elliptical nor tendentious (I am not sure I fully succeed). The second concern involves the charge, often raised against semi-surrealist artists like Gober and semi-psychoanalytical critics like me, that we are illustrational — that the first represents, and the second encodes, a given idea, say, of the unconscious, desire, fantasy. I do not think this happens here. No serious work, artistic or critical, illustrates theory: it is theoretical in its own terms — it disturbs or otherwise develops theory — or it is not theoretical at all.

6. Freud added another primal fantasy, an intrauterine one, which might serve psychically as a salve to the other, traumatic fantasies, especially of castration, to which it only seems anterior. See, among other texts, "The Sexual Enlightenment of Children" (1907), "On the Sexual Theories of Children" (1908), "Leonardo da Vinci and a Memory of His Childhood" (1910), and "The History of an Infantile Neurosis" (the Wolf Man case history, 1914/18). For the relation of primal fantasies to surrealist aesthetics, which Gober elaborates, see my *Compulsive Beauty* (Cambridge: The MIT Press, 1993). Of course, then and now, the notion of primal fantasy, let alone the hypothesis of seduction, is very controversial. For a recent intervention in the debate see Mikkel Borch-Jacobson, "Neurotica: Freud and the Seduction Theory," *October* 76 (Spring 1996).

7. "The whole of the trauma comes *both* from within and without," Jean Laplanche and Jean-Bertrand Pontalis write in relation to seduction in particular. "From without, since sexuality reaches the subject from *the other*; from within, since it springs from this internalized exteriority, this '*reminiscence* suffered by hysterics' (according to the Freudian formula)." See "Fantasy and the Origins of Sexuality" (1964), in Victor Burgin, James Donald, and Cora Kaplan, eds., *Formations of Fantasy* (London: Metheun, 1986), 5-34, here p. 10. This remains the most useful explication of the notion of primal fantasy.

8. Ibid., 26.

9. André Breton, *Manifestoes of Surrealism*, trans. Richard Seaver and Helen R. Lane (Ann Arbor: University of Michigan, 1972), 21

10. André Breton, *Nadja*, trans. Richard Howard (New York: Grove Press, 1960), 11-12.

11. See Jean Laplanche, *New Foundations for Psychoanalysis*, trans. David Macey (Oxford: Basel Blackwell, 1989). Laplanche has long questioned the Lacanian insistence on the unconscious structured as a language; his signifiers can be "verbal, nonverbal, and even behavioral," as long as they are "pregnant with unconscious sexual significations" (p. 126). Incidentally, they may be enigmatic for the other, too: "As I see it, enigma is defined by the fact that it is an enigma even for the one who sends the enigma." (Laplanche, *Seduction, Translation, Drives*, trans. Martin Stanton [London: Institute of Contemporary Arts, 1992], 57).

12. This affect may be related to what Freud called the helplessness (*Hilflosigkeit*) of the infant in the traumatic event, to what the surrealists called the availability (*disponibilité*) of the artist before the uncanny, and, more distantly, to what Keats called the negative capability of the poet in inspiration. Lacan captures this state between anxiety and ecstasy with the ambiguous phrase *en souffrance*, which suggests both suspension and sufferance — a condition that is also evoked by such gay precedents of Gober as Jasper Johns and Andy Warhol.

13. Or the taboo of literature: the first incarnation of this velvet and foam-rubber breast was as the cover of the catalogue *Le Surréalisme en 1947*.

14. Laplanche, *New Foundations*, 126.

15. Sigmund Freud, "Three Essays on the Theory of Sexuality" (1905), in *On Sexuality*, ed. Angela Richards (London: Penguin Books, 1977), 145.

16. For me the amputated legs suggest a loss in the self, while the legs planted with candles evoke a loss of an other, but this may depend on the positioning, sexual and otherwise, of the viewer.

17. Gober can evoke violation, humor, pathos, and humiliation — all at once. The legs planted with candles recall the haunting dream, told by Freud and repeated by Lacan, of the father who falls asleep while his dead son lies in the next room. In the dream the father imagines, in a self-reproach, that the room is on fire and that he has failed once again to save his son, who appears to admonish him: "Father, can't you see I'm burning?"

18. For "traumatic realism" in Warhol, see my "Death in America," *October* 75 (Winter 1996), and *The Return of the Real* (Cambridge: The MIT Press, 1996), chapter 5. In his interview, Richard Flood reduces such elaborations to "critical gamesmanship" (p. 14), but this little cynicism misses a major significance of Gober. Apart from Duchamp, one also thinks of René Magritte, especially his simulacral scenes of fantasy, and, again, of

Giacometti. Long ago Michel Leiris captured the aesthetic of Giacometti in a way that resonates with Gober today:

"There are moments that can be called *crises*, the only ones that count in a life. There are moments when abruptly the outside seems to respond to a call we send it from within, when the exterior world opens itself and a sudden communion forms between it and our heart. From my own experience I have several memories like this, and they all relate to events that seem trifling, without symbolic value, and one might say *gratuitous*... Poetry can emerge only from such 'crises,' and the only worthwhile works of art are those that provide their equivalents.

"I love Giacometti's sculpture because everything he makes is like the petrification of one of these crises, the intensity of a chance event swiftly caught and immediately frozen, the stone stele telling its tale. And there's nothing deathlike about this sculpture; on the contrary, like the real fetishes we idolize (real fetishes, meaning those that resemble us and are objectivized forms of our desire) everything here is prodigiously alive — graciously living and strongly shaded with humor, nicely expressing that affective ambivalence, that tender sphinx we nourish, more or less secretly, at our core." (*Documents* 1, no. 4 [1929], 209-210.)

19. Marcel Duchamp, "Apropos of 'Readymades'" (1961), in *The Essential Writings of Marcel Duchamp*, ed. Michel Sanouillet and Elmer Peterson (London: Thames and Hudson, 1975), 141.

20. For a very suggestive typology of modern sculpture in which these two models are opposed, see Rosalind Krauss, "Bachelors," *October* 52 (Spring 1990).

21. Robert Gober quoted in *Parkett*, no. 27 (March 1991).

22. In a famous passage in *Black Skin, White Masks* (New York: Grove Press, 1967 [1952]), Frantz Fanon stages the moment of his racial marking as a social primal scene. For related encounters in modernist art, see my "'Primitive' Scenes," *Critical Inquiry* (Autumn 1993).

 Some of the Gober body parts evoke historical events of torture and murder. For example, the butts tattooed with music evoke the coding of Jews in death camps (the image is derived from the depiction of hell in *The Garden of Earthly Delights* by Hieronymus Bosch). Gober again made this connection in a little diorama (1994-95) first displayed in Basel: here we look through bent bars into a brick space with a mass of white sandaled legs — a monument that points to gas chambers and mass graves alike.

23. I presume her to be white — but then why should I? For that matter, why do I presume the absent bride to be female? (In some of his revised pages from *The New York Times*, Gober has slipped his own body into the bridal wear advertised there.) Thus do these images catch one up in ideological assumptions.

24. A fitting gloss on the installation is the extraordinary meditation on the trauma of racial and sexual oppression by William Faulkner in *Absalom! Absalom!*.

25. Jean-François Lyotard, *Les TRANSformateurs DUchamp* (Paris: Galilée, 1977), 137-38.

26. Lacan, *The Four Fundamental Concepts of Psychoanalysis*, trans. Alan Sheridan (New York: W. W. Norton, 1981 [1973]), 77. In *The Optical Unconscious* (Cambridge: The MIT Press, 1993), Rosalind Krauss complements this Lacanian account of perspective, of difference in vision, with a Sartrean reading that complicates the position of the viewer on this side of the diorama, in the public space of the museum: not only is our gaze inflected by sexual difference, but as viewers in a public space we are under the gaze of others, caught in the act of the peeping Tom (which, retrospectively at least, is the position of us all in the primal scene). Yet, even as there is shame in this looking, there is pleasure, too — the pleasure not only of the voyeur but of the reciprocal figure, the exhibitionist. That is, might we not also identify with the exhibitionistic position of the mannikin, even as we gaze at her voyeuristically? As I suggested at the outset, this reciprocality is also put into play by Gober.

27. Laplanche, *New Foundations*, 45. For Laplanche the crucial aspect of the enigmatic signifier is not its meaning but its address — its "power to signify *to*."

28. Gober, "Interview with Richard Flood."

29. In a new work on Caravaggio (forthcoming from The MIT Press) Leo Bersani and Ulysse Dutoit argue that the enigmatic signifier locks the primal couple of parent and infant in a relation of paranoid fascination that is then replicated in other relations throughout life. And they explore the particular ways that Caravaggio plays pictorially with such fascination — on occasion to offer potential forms of release from it. Gober operates within this fascination; his work suggests that there is no outside.

30. See *The Return of the Real*, chapter 5. Perhaps the paragon of such art is the piece, part performance, part installation, conceived by Patrick McGrath in "The Smell" (in *The New Gothic*, ed. Bradford Morrow and Patrick McGrath [New York: Random House, 1991], 241-47). In this story a tyrannical father, isolated in his familial house, begins to smell an odor that no one else can sense. Gradually he traces it to a barred room downstairs, where he is inexorably drawn: "like a moth to a flame, it was *pulling me in*." At last he discovers the foulness in a chimney, which he enters, only to become stuck. "A voice inside my own brain whispered, You're suffocating, you're going to die. You're going to die. You're going to die in this putrid chimney. And *then* the thought, So is it *me*? Is it me who makes the smell? Am I the thing that drips and stinks?"

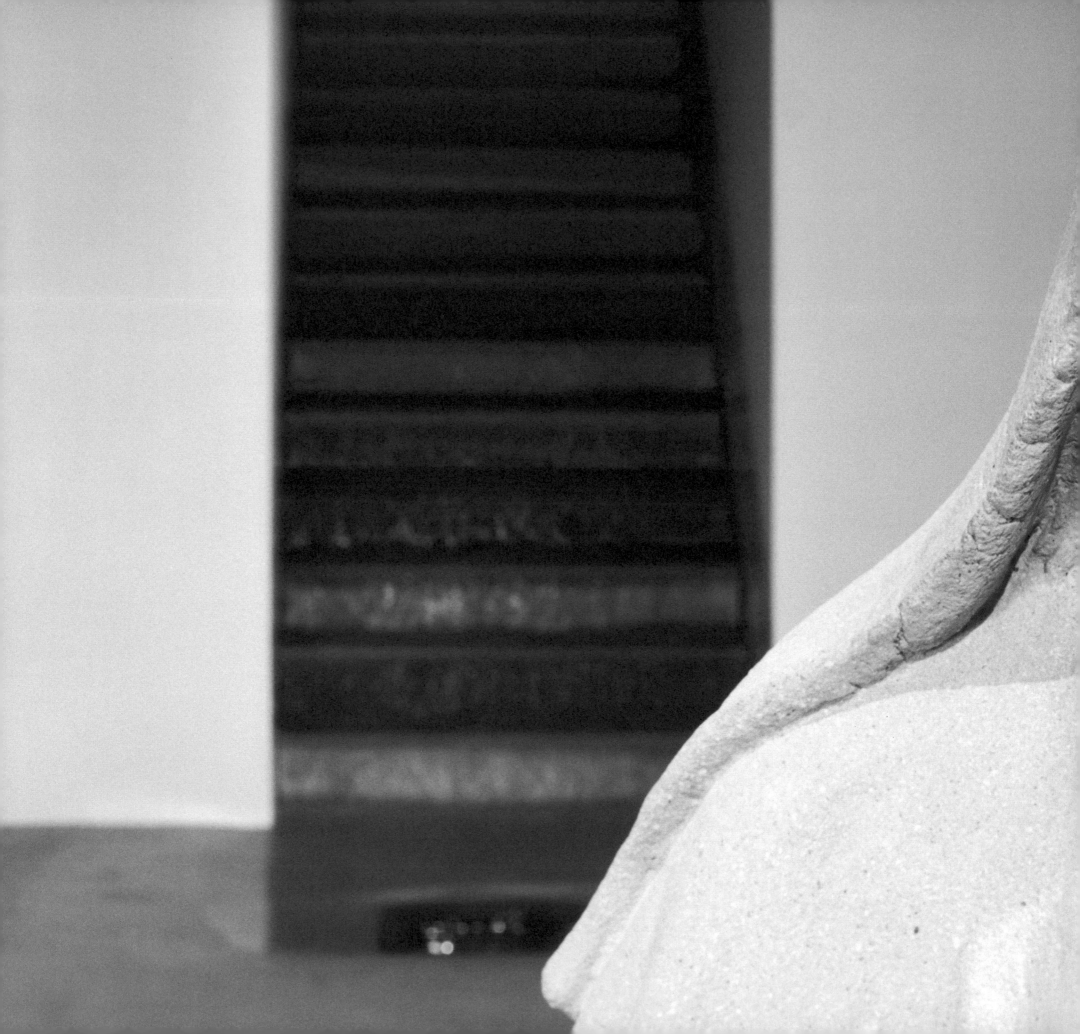

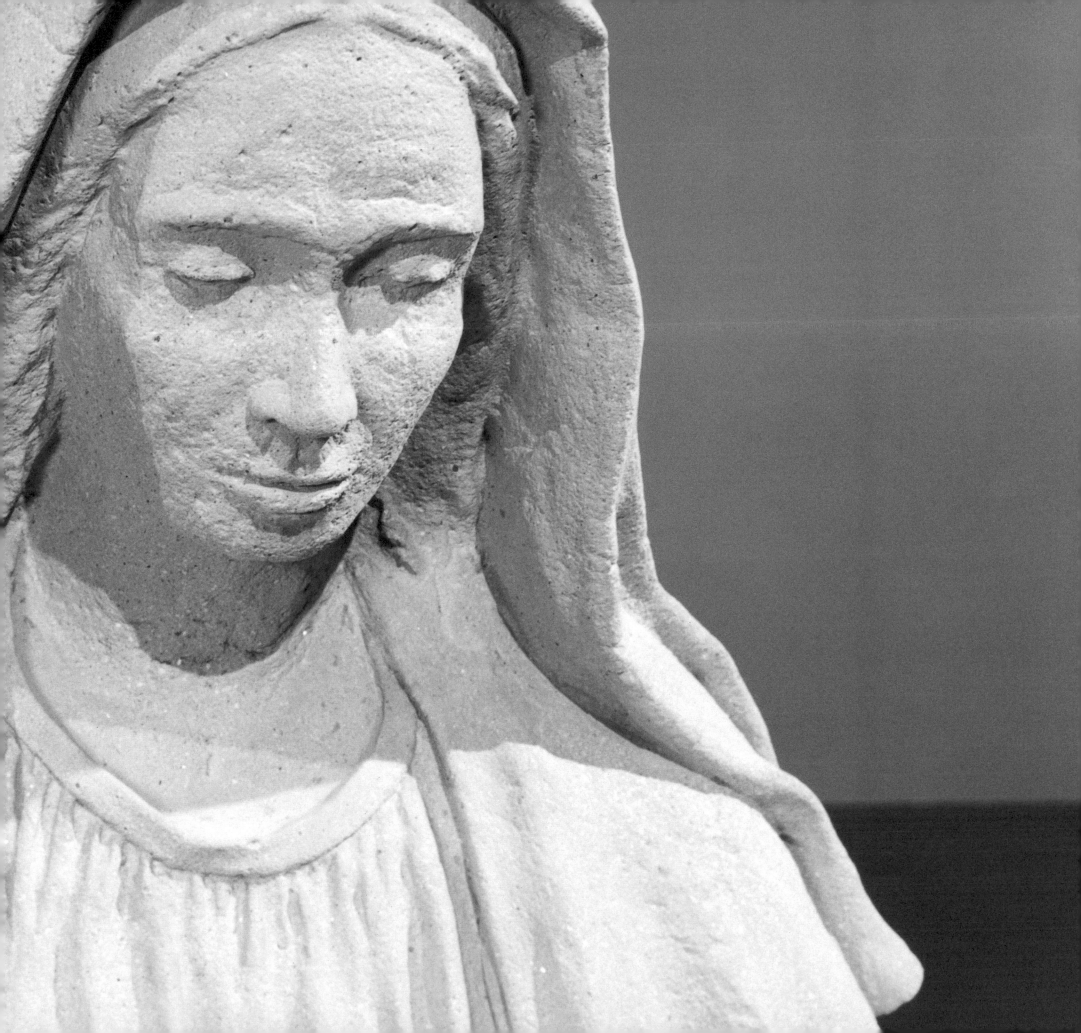

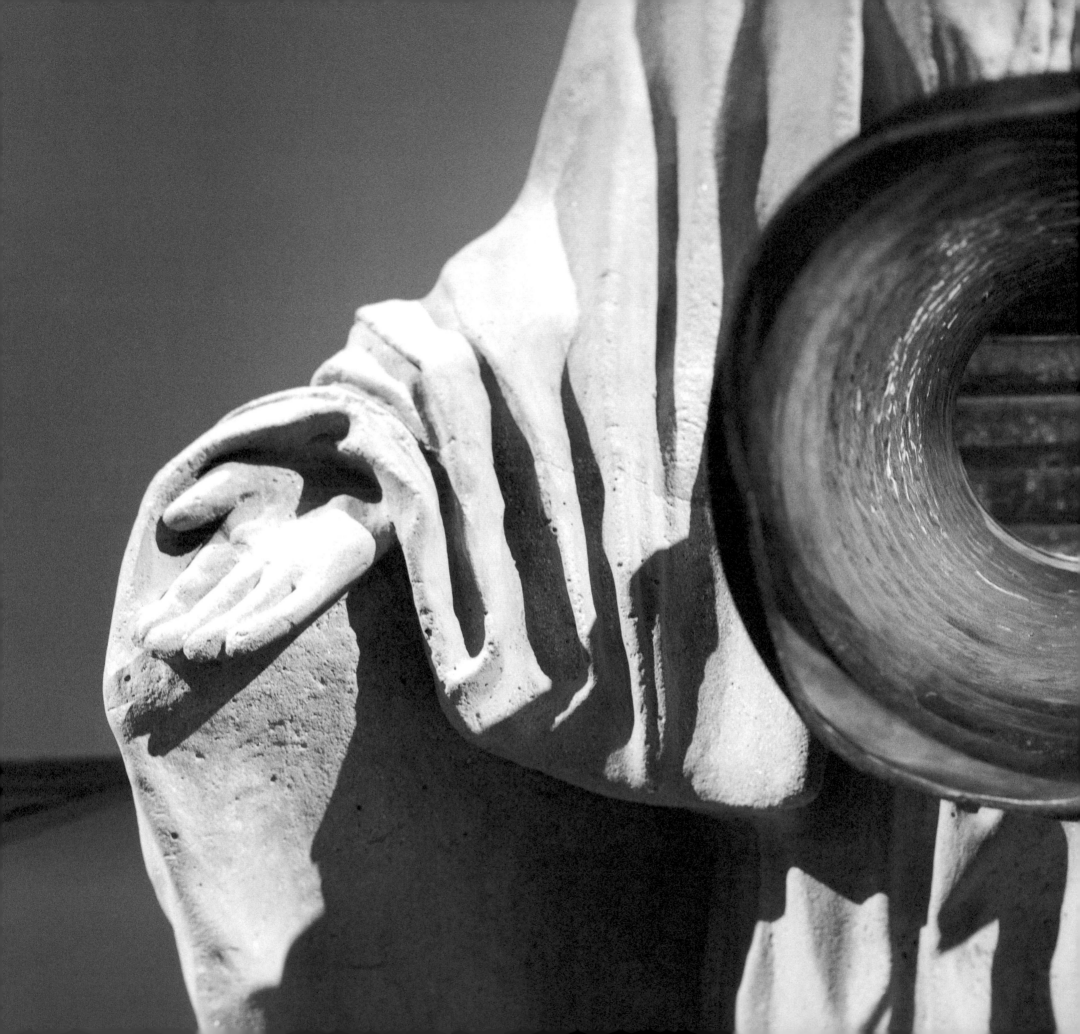

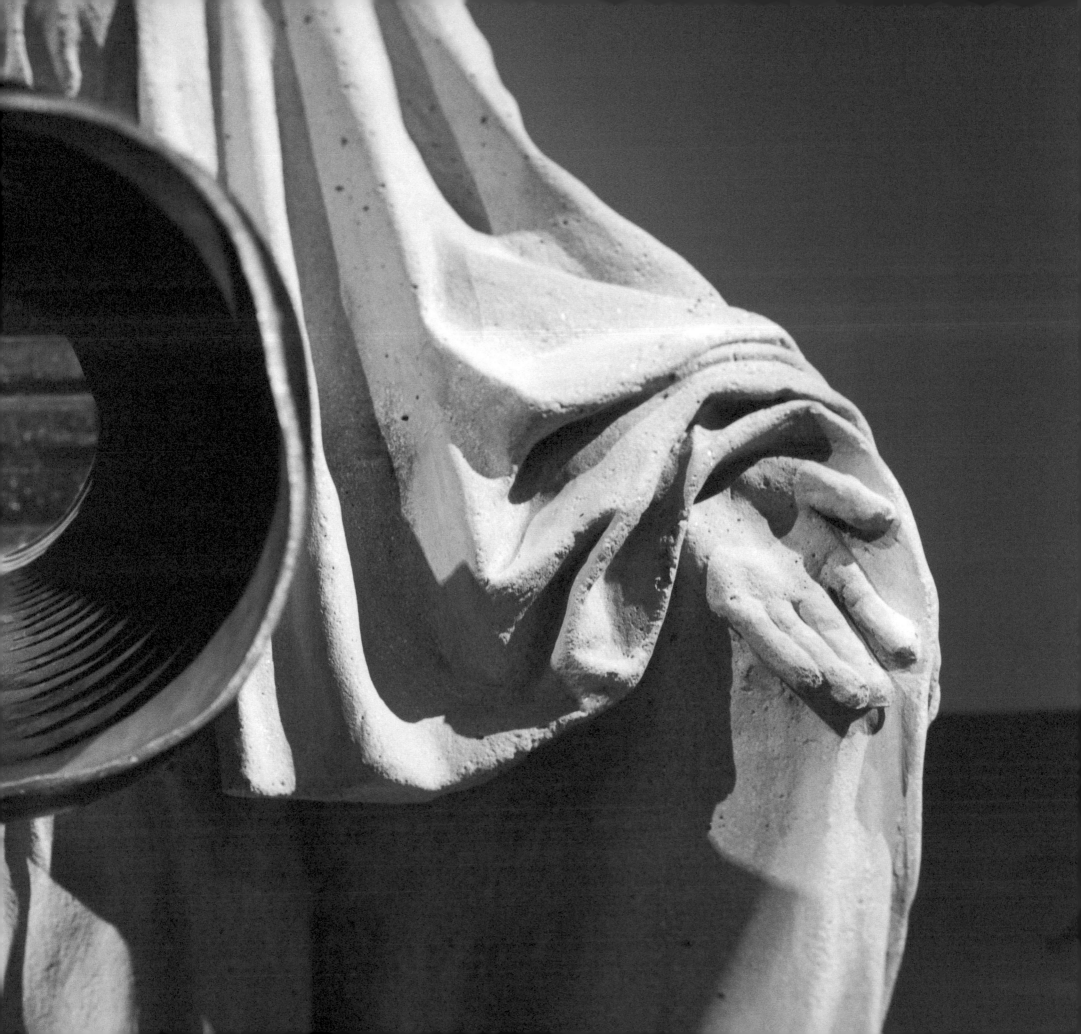

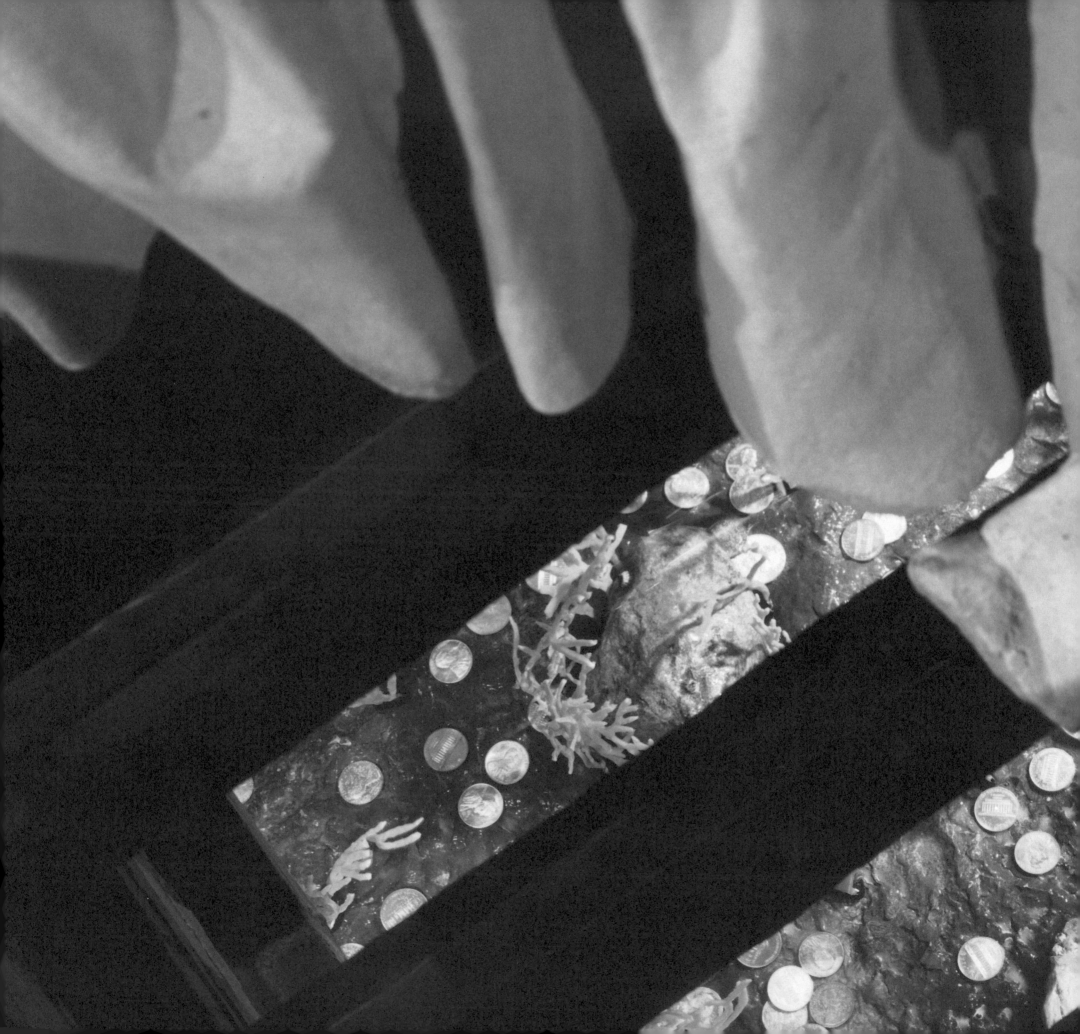

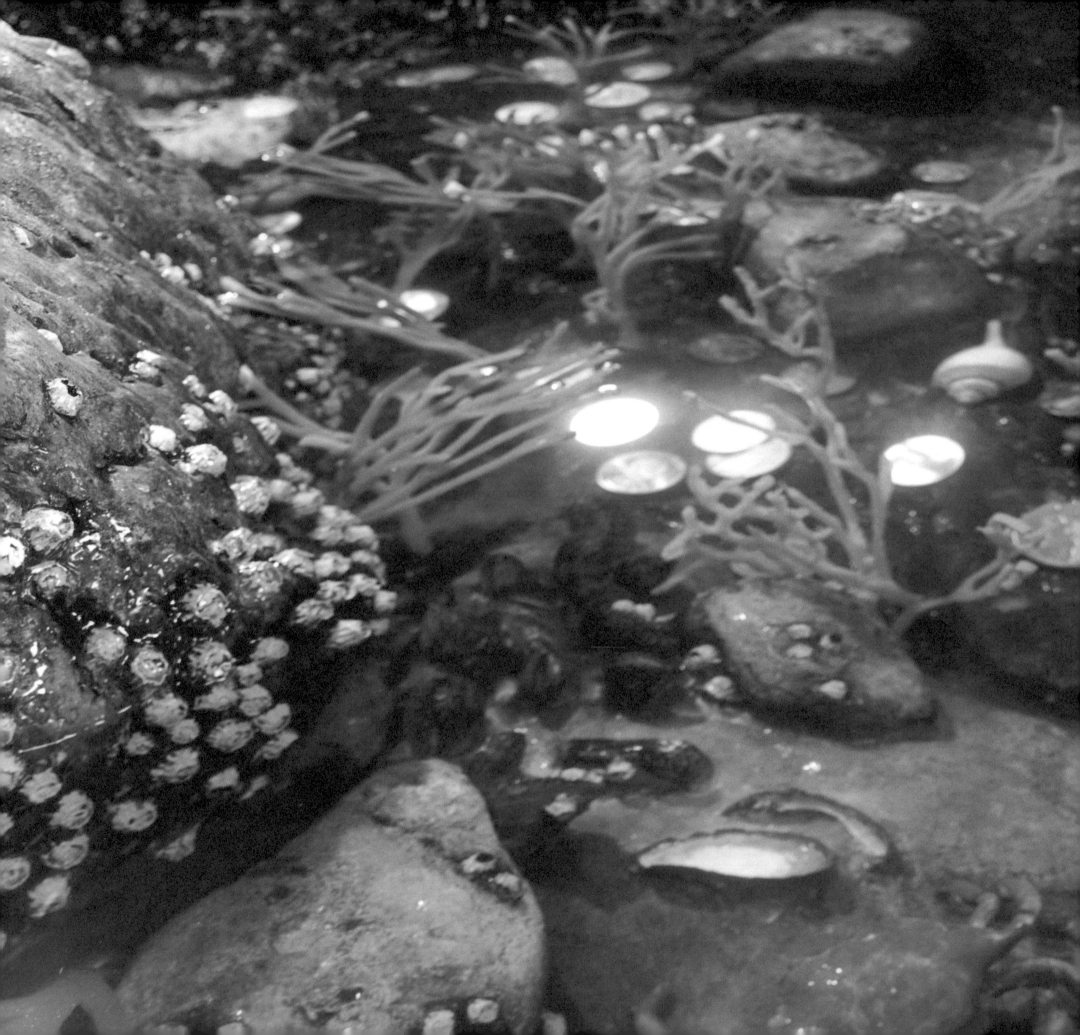

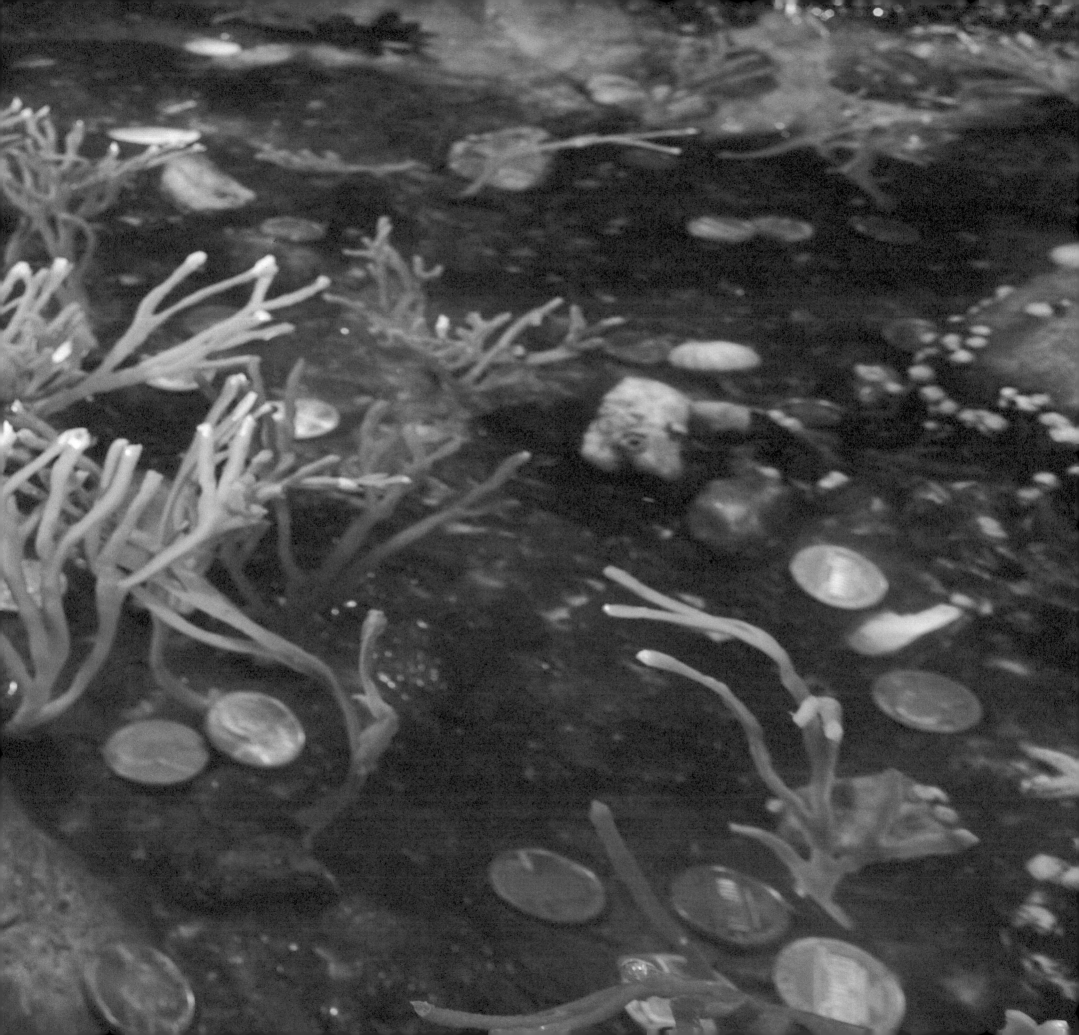

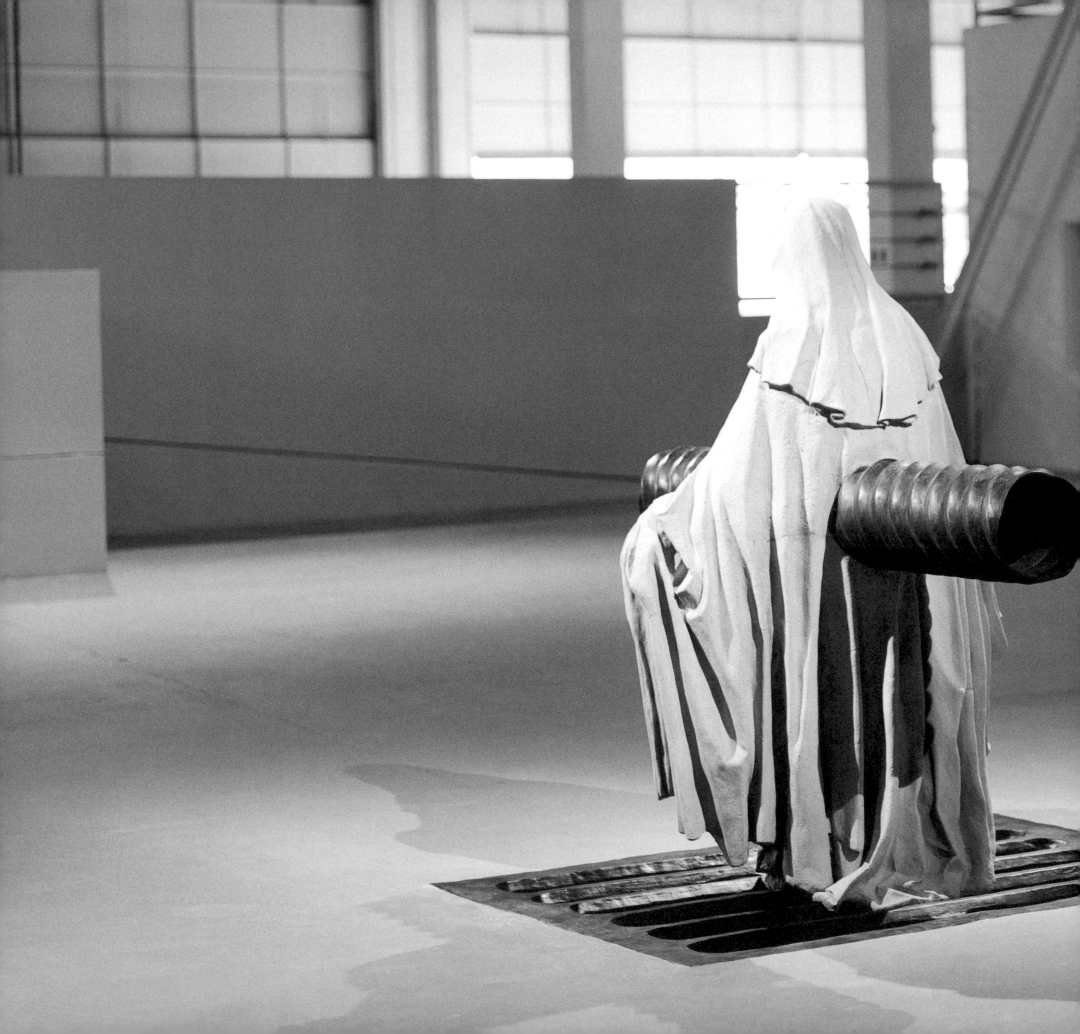

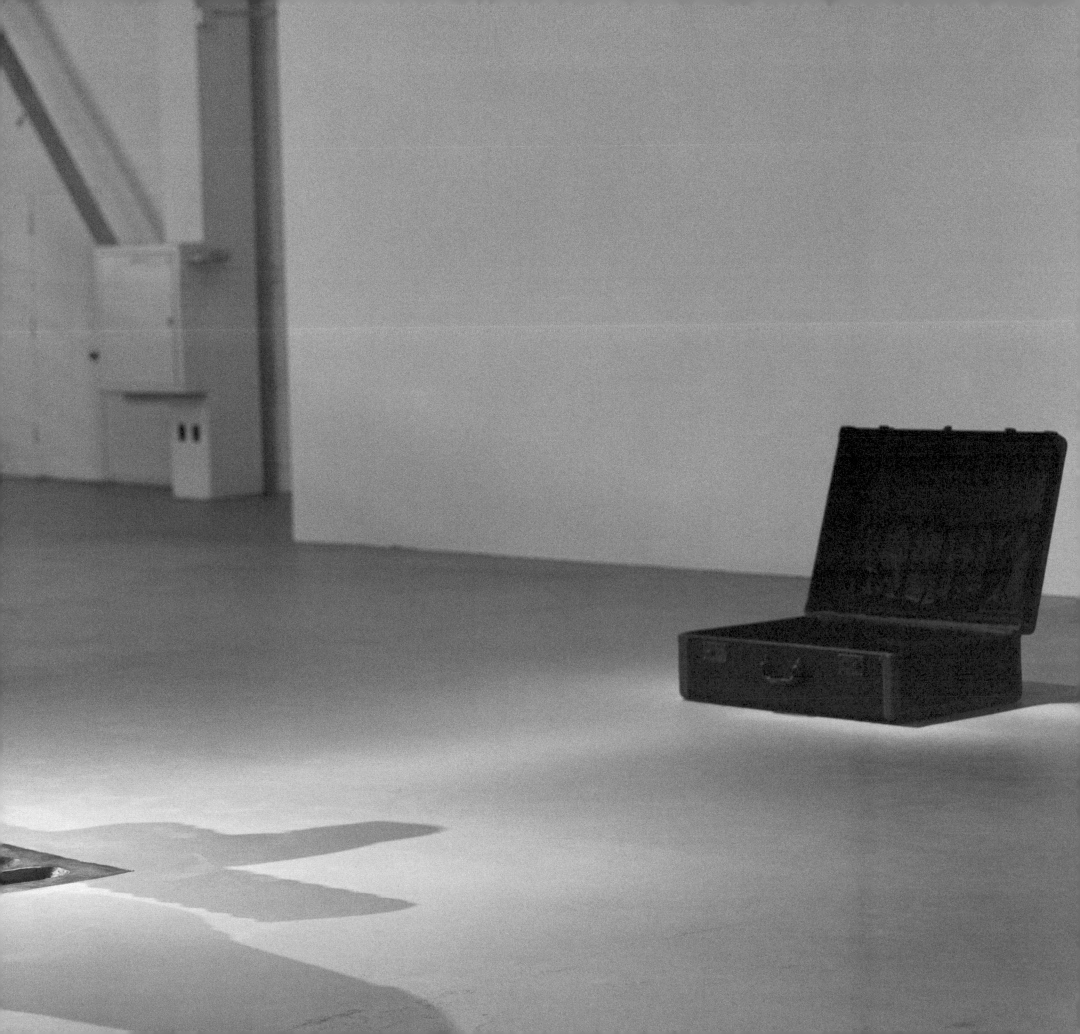

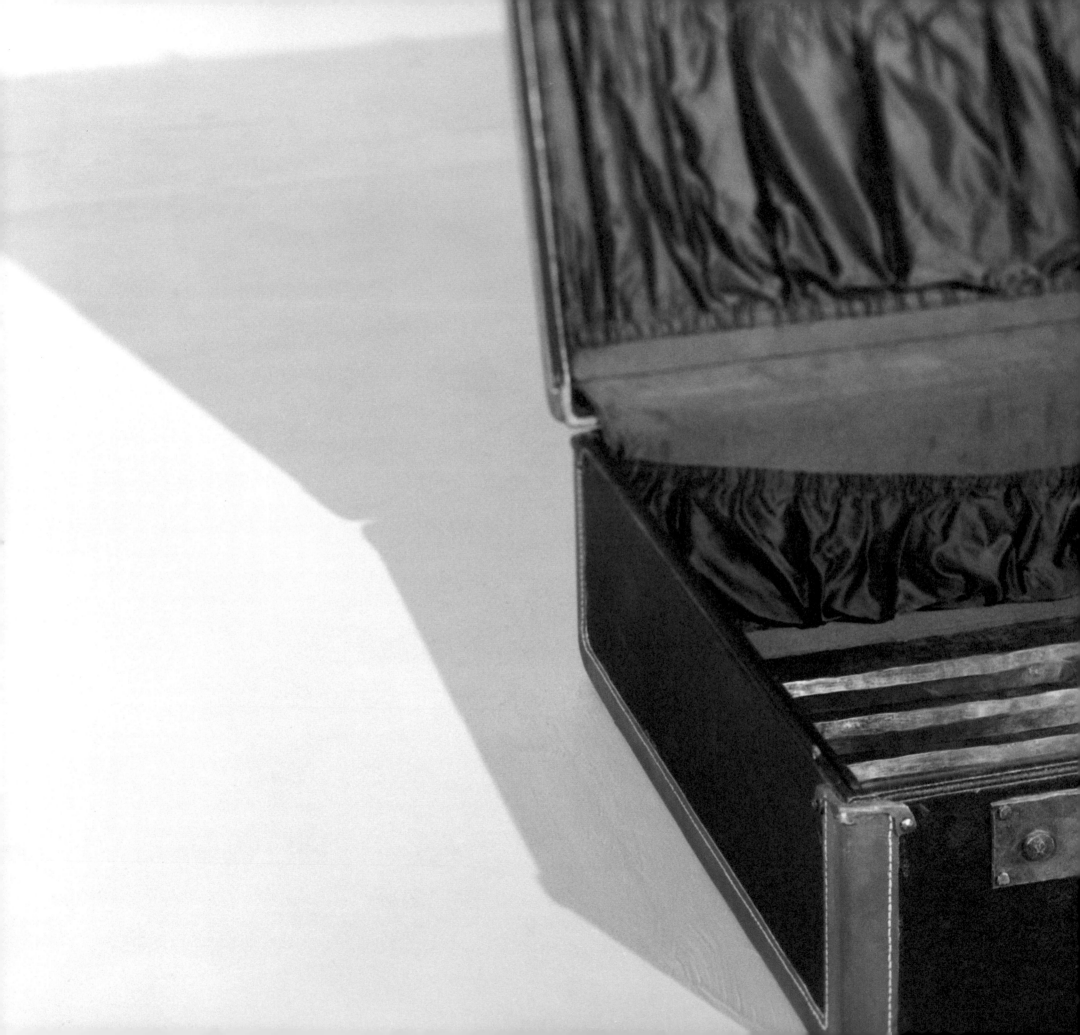

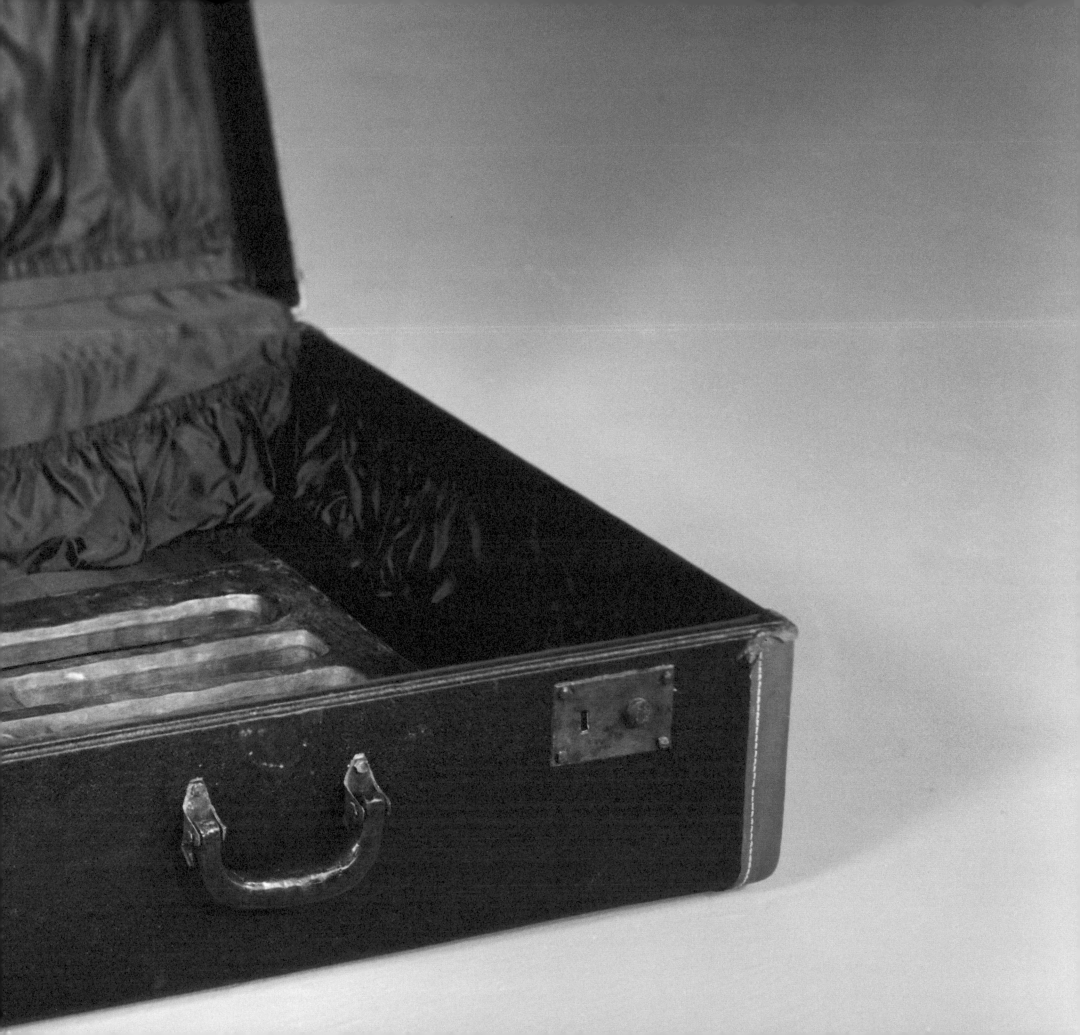

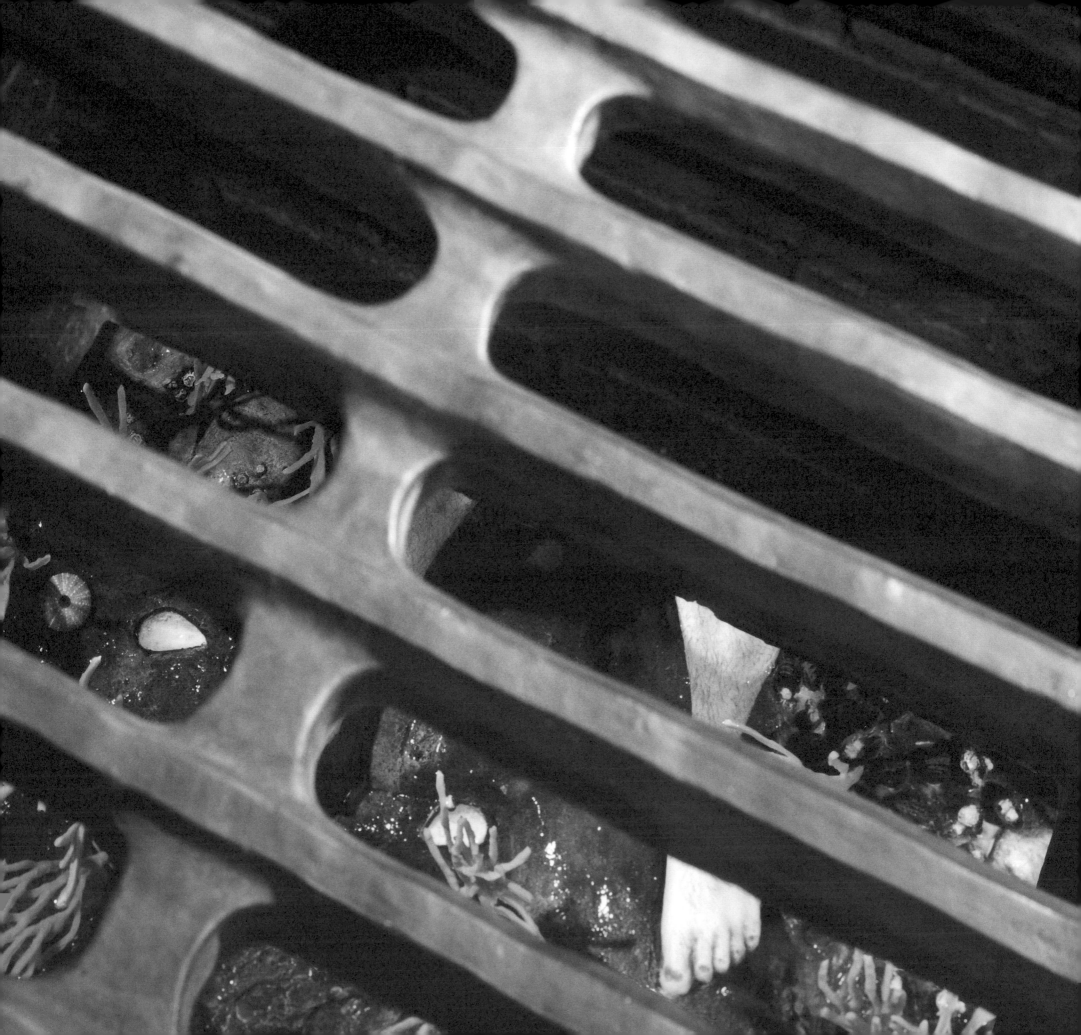

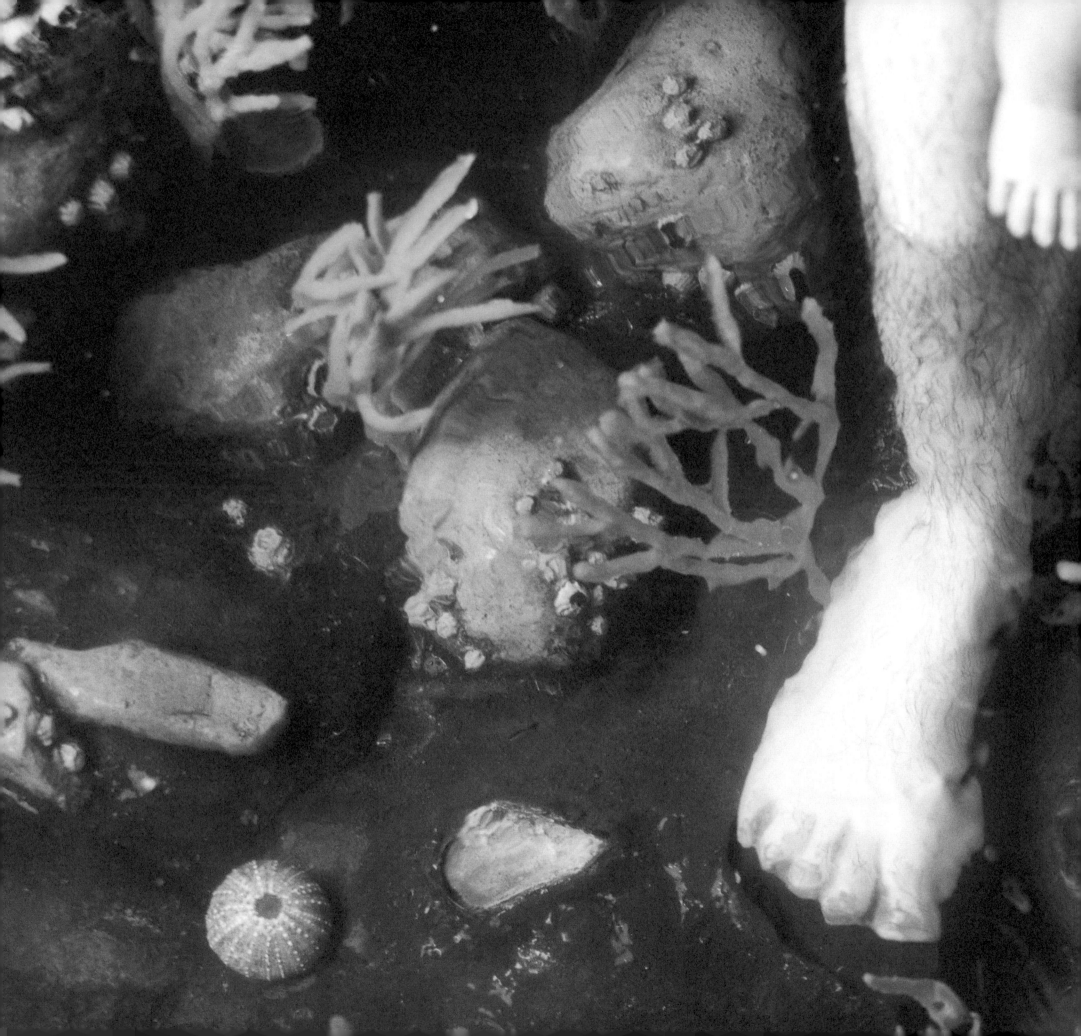

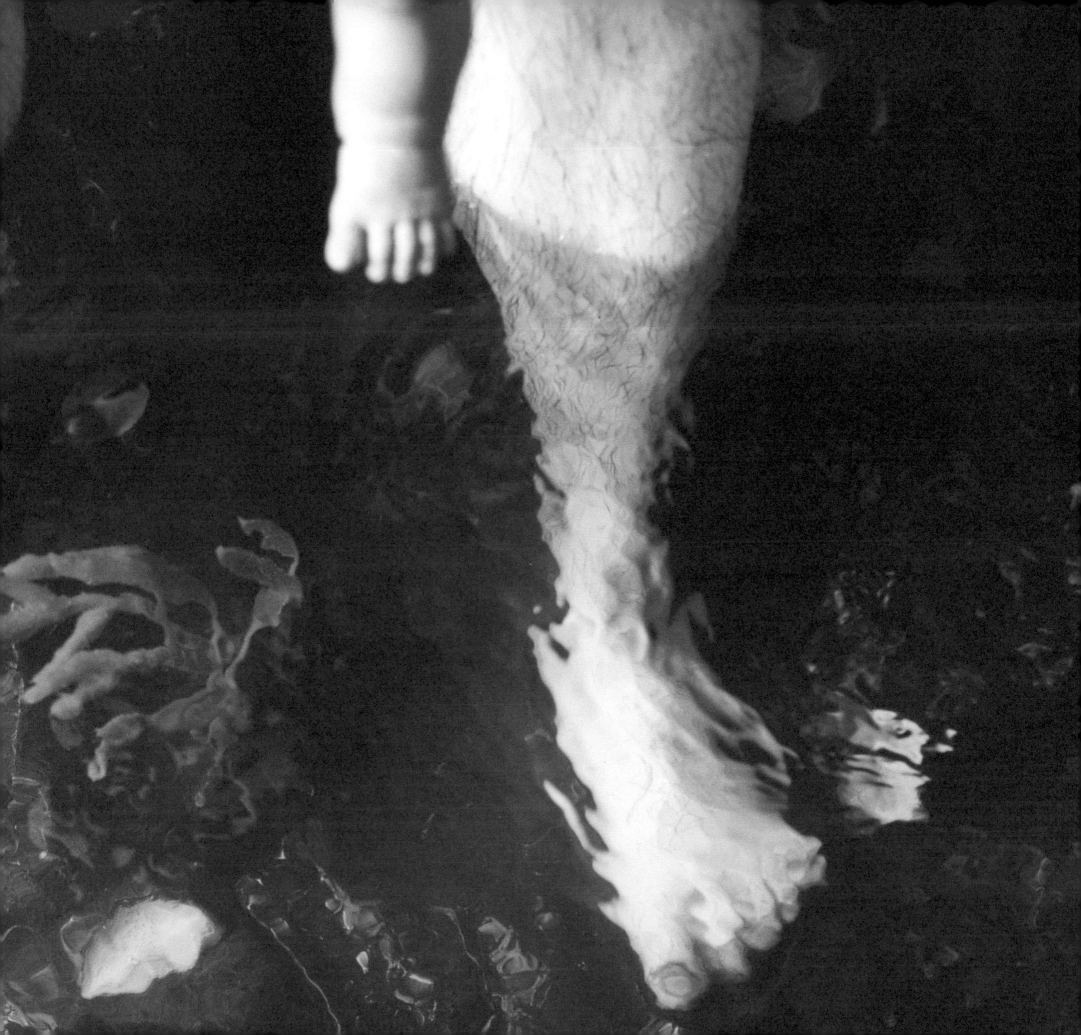

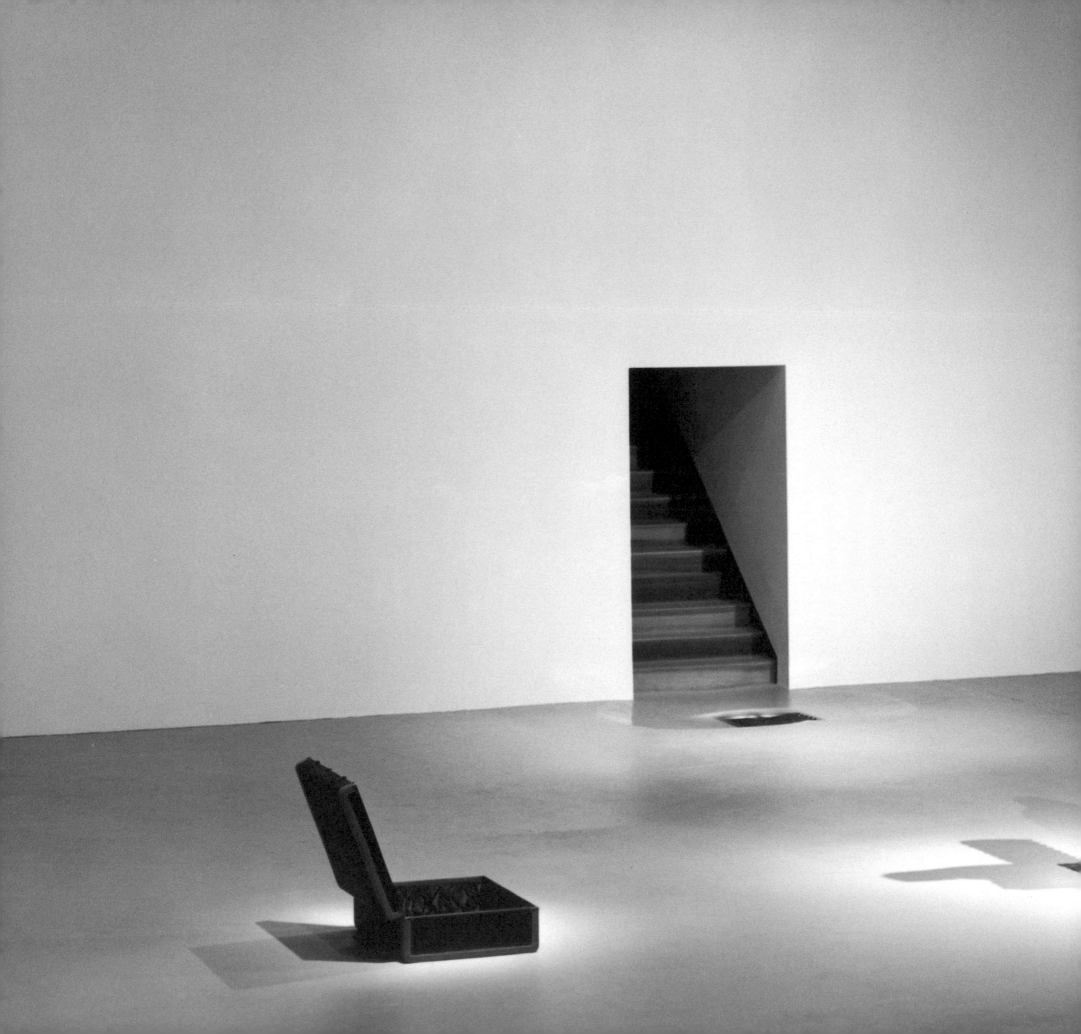

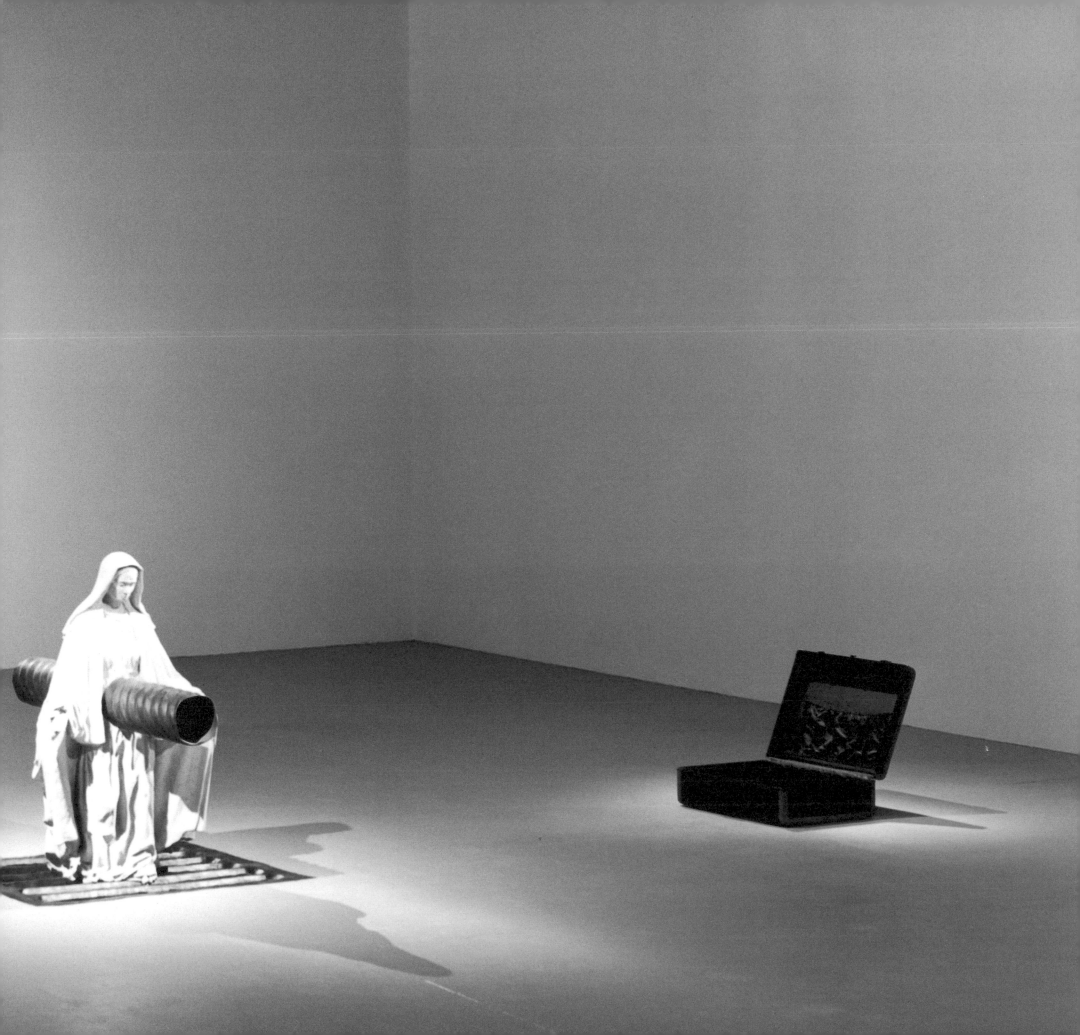

Untitled, 1995-97

Dimensions:

Figure: Cast concrete, bronze, steel, copper, nickel silver, brick, fiberglass, urethene, cast plastics, paint, lead, motors, water.

Overall: 13 ft. 3 in. x 9 ft. 9 in. x 7 ft. 10 in.
Above ground: 5 ft. 10 in. x 5 ft. 10 ¼ in. x 5 ft. 10 ½ in.
Below ground: 7 ft. 5 in. x 9 ft. 9 in. x 7 ft. 10 in.

Staircase: Cedar, bronze, steel, brick, fiberglass, urethene, cast plastics, paint, lead, pumps, water.
Overall: 29 ft. 9 in. x 8 ft. 4 in. x 25 ft. (with a 6 in. puddle variable)
Above ground: 22 ft. 6 in x 8 ft. 4 in. x 23 ft
Below ground: 7 ft. 3 in. x 6 ft. 3 in. x 8 ft. 8 in.

Suitcases: Leather, wood, forged iron, cast plastics, bronze, silk, satin, steel, wax, human hair, brick, fiberglass, urethene, paint, lead, motors, water.

Overall: 10 ft. 2 ½ in. x 8 ft. 8 in. x 6 ft. 3 in.
Above ground: 2 ft. 11 ½ in. x 2 ft. 11 ½ in. x 3 ft. 4 in.
Below ground: 7 ft. 3 in. x 8 ft. 8 in. x 6 ft. 3 in.

Robert Gober

One-Person Exhibitions

1984
"Slides of a Changing Painting," Paula Cooper Gallery, New York.

1985
Daniel Weinberg Gallery, Los Angeles.
Paula Cooper Gallery, New York.

1986
Daniel Weinberg Gallery, Los Angeles.

1987
Galerie Jean Bernier, Athens.
Paula Cooper Gallery, New York.

1988
Tyler Gallery, Tyler School of Art, Temple University, Philadelphia.
"Robert Gober," The Art Institute of Chicago, Chicago.
Galerie Max Hetzler, Cologne.
Galerie Gisela Capitain, Cologne.

1989
Paula Cooper Gallery, New York.

1990
Galleria Marga Paz, Madrid.
Museum Boymans-van Beuningen, Rotterdam, and Kunsthalle Bern, Bern.

1991
Galerie nationale du Jeu de Paume, Paris, and Museo Nacional
 Centro de Arte Reina Sofia, Madrid.

1992
Dia Center for the Arts, New York.

1993
Serpentine Gallery, London, and Tate Gallery, Liverpool.

1994
Paula Cooper Gallery, New York.
"Robert Gober. Dessins," Galerie Samia Saouma, Paris.

1995
Galerija Dante Marino Cettina, Umag.
"Robert Gober," Museum für Gegenwartskunst, Basel.

1996
Galerie Max Hetzler, Berlin.

1997
Paula Cooper Gallery, New York.
The Museum of Contemporary Art, Los Angeles.

Group Exhibitions

1979
112 Greene Street, New York.

1981
"Three Look into American Home Life," Ian Berkstedt Gallery, New York.

1982
Paula Cooper Gallery, New York.
Paula Cooper Gallery, New York.

1983
Barbara Toll Fine Arts, New York.
"New York Work," Studio 10, Chur.

1984
"Artists Choose Artists," Jus de Pomme, New York.
P.S. 122, New York.
Paula Cooper Gallery, New York.

1985
"A Benefit Auction for Gay Men's Health Crisis," Daniel Weinberg Gallery,
 Los Angeles.
Paula Cooper Gallery, New York.
"Scapes," University Art Museum, Santa Barbara, and The Art Gallery,
 University of Hawaii at Manoa, Honolulu.
Paula Cooper Gallery, New York.
"Benefit for the Kitchen," Brooke Alexander Gallery, New York.
"Drawing," Knight Gallery, Charlotte.

1986
"Robert Gober, Jeff Koons, Peter Nadin, Meyer Vaisman," Jay Gorney Modern
 Art, New York.
"Objects from the Modern World: Richard Artschwager, R.M. Fischer, Robert
 Gober, Jeff Koons," Daniel Weinberg Gallery, Los Angeles.
"Robert Gober and Kevin Larmon: An Installation," Gallery Nature Morte,
 New York.
"Large Scale Works by Gallery Artists," Paula Cooper Gallery, New York.
"New Sculpture: Robert Gober, Jeff Koons, Haim Steinbach," The Renaissance
 Society at the University of Chicago, Chicago.
Paula Cooper Gallery, New York.
Paula Cooper Gallery, New York.
"Robert Gober, Nancy Shaver, Alan Turner, Meg Webster," Cable Gallery,
 New York.
"Works from the Paula Cooper Gallery," John Berggruen Gallery, San Francisco.
"1976-1986: Ten Years of Collecting Contemporary American Art (Selections from
 the Edward R. Downe, Jr. Collection)," Wellesley College Museum, Wellesley.
Galerie Max Hetzler, Cologne.
"Art on Paper Exhibition," Weatherspoon Art Gallery, The University of North
 Carolina at Greensboro, Greensboro.
"Art for Young Collectors," The Renaissance Society at the University of Chicago,
 Chicago.
Paula Cooper Gallery, New York.
"Drawings," Gallery Casas Toledo Oosterdom, New York.
"Art and Its Double: Recent Developments in New York Art," La Fundacio Caixa
 de Pensiones, Barcelona, and Fundacio Caixa de Pensiones, Madrid.

1987
"The Great Drawing Show 1587-1987," Michael Kohn Gallery, Los Angeles.
"Artists from Paula Cooper Gallery," Galeria EMI - Valentim de Carvalho, Lisbon.
"Extreme Order," Lia Rumma, Naples.
"Avant Garde in the Eighties," Los Angeles County Museum of Art, Los Angeles.
Crousel-Hussenot, Paris.
"Art Against Aids: A Benefit Exhibition," Paula Cooper Gallery, New York.
"New York Art Now: The Saatchi Collection (Part I)," The Saatchi Collection,
 London.
"Drawn Out: An Exhibition of Drawings by Contemporary Artists," Kemper
 Gallery, Kansas City Art Institute, Kansas City.

1988

"Real Inventions/Invented Functions," Laurie Rubin Gallery, New York.
"Cultural Geometry," Deka Foundation, House of Cypres, Athens.
"Utopia Post Utopia," The Institute of Contemporary Art, Boston.
"Works on Paper," Curt Marcus Gallery, New York.
"New York Art Now: The Saatchi Collection (Part II)," The Saatchi Collection, London.
"Sculpture Parallels," Sidney Janis Gallery, New York.
"Artschwager: His Peers and Persuasion (1963-1988)," Daniel Weinberg Gallery, Los Angeles; Leo Castelli Gallery, New York.
"Verken Van," Galerij Micheline Szwajcer, Antwerp.
"Robert Gober, Christopher Wool," 303 Gallery, New York.
"Furniture as Art," Museum Boymans-van Beuningen, Rotterdam.
"Eleven Artists from Paula Cooper Gallery," Mayor Rowan Gallery, London.
"Sculpture: Inside Outside," Walker Art Center, Minneapolis, and The Museum of Fine Arts, Houston.
"La Biennale di Venezia: XLIII Esposizione International d'Arte 1988," Venice.
"Art at the End of the Social," Rooseum Gasverksgatan, Malmö.
"The Binational: American Art of the Late 80's," Museum of Fine Arts, Boston, and Kunsthalle, Dusseldorf.
"Innovations in Sculpture," The Aldrich Museum of Contemporary Art, Ridgefield.
"Dan Flavin, Robert Gober, Yves Klein," 303 Gallery, New York.
"In the Making: Drawings by Sculptors," The Sculpture Center, New York.
"New Works by Ashley Bickerton, Robert Gober, Peter Halley, Jeff Koons, Richard Prince, Meyer Vaisman and Christopher Wool," Daniel Weinberg Gallery, Los Angeles.

1989

"Horn of Plenty: Sixteen Artists from New York City," Stedelijk Museum, Amsterdam.
"Abstraction in Question," The John and Mable Ringling Museum of Art, Sarasota, and Center for the Fine Arts, Miami.
Paula Cooper Gallery, New York.
"Pre-Pop, Post-Appropriation," Stux Gallery, New York.
"Whitney Biennial," Whitney Museum of American Art, New York.
"Coleccion de Dibujos," Galeria La Maquina Espanola, Madrid.
"A Decade of American Drawing 1980-1989," Daniel Weinberg, Los Angeles.
"Psychological Abstraction," Deste Foundation for Contemporary Art, Athens.
"Filling in the Gap," Feigen, Inc., Chicago.
"The Play of the Unsayable: Ludwig Wittgenstein and the Art of the 20th Century," Weiner Secession, Vienna, and Palais des Beaux Arts, Brussels.
"Gober, Dujourie, Horndash, Munoz, van Oost," Wolff Gallery, New York.
"Gober, Halley, Kessler, Wool: Four Artists from New York," Kunstverein München, Munich.
"Graduate Exhibit," Starr Library, Special Collections, Middlebury.
"Hybrid Neutral, Modes of Abstraction and the Social," The University of North Texas Art Gallery, Denton; The J.B. Speed Art Museum, Louisville; Alberta College Gallery of Art, Calgary, Alberta; The Contemporary Arts Center, Cincinnati; Richard F. Brush Art Gallery, St. Lawrence University, Canton; Santa Fe Community College Art Gallery, Gainesville.
"Dream Reality," The School of the Visual Arts Gallery, New York.
"Another Focus," Karsten Schubert Ltd., London.
"Einleuchten: Will, Vorstel, und Simul in HH," Deichtorhallen, Hamburg.
"Robert Gober and Bruce Nauman," Galerij Micheline Szwajcer, Antwerp.

1990

"Works from Rudolf and Ute Scharpff's Collection," Staatsgalerie Stuttgart, Stuttgart.
"The Clinic," Simon Watson, New York.
"Editionen," Galerie Gisela Capitain, Cologne.
"Culture and Commentary: An Eighties Perspective," Hirshhorn Museum and Sculpture Garden, Washington, D.C..
"Gunther Forg, Kenji Fujita, Robert Gober, Georg Herold, Jon Kessler, Liz Larner, Zoe Leonard," Luhring Augustine, New York.
"New Work: A New Generation," San Francisco Museum of Modern Art, San Francisco.
"Status of Sculpture," L'Espace Lyonnais d'Art Contemporian, Centre d' Echanges de Perrache, Lyon; Institute of Contemporary Art, London; Museum of Hasselt, Stiftung Starke, Berlin.
"White Columns Twentieth Anniversary Benefit Exhibition," White Columns, New York.

"Drawings," Burnett Miller Gallery, Los Angeles.
"Objectives: The New Sculpture," Newport Harbor Art Museum, Newport Beach.
"The Readymade Boomerang: Certain Relations in 20th Century Art, The Biennale of Sydney 1990," Art Gallery of New South Wales, Sydney.
"The Kitchen Art Benefit," Curt Marcus Gallery and Castelli Graphics, New York.
Paula Cooper Gallery, New York.
Barbara Gladstone Gallery, New York.
"Sculpture," Daniel Weinberg Gallery, Santa Monica.
"In Memory of James 1984-1988: The Children's AIDS Project," Daniel Weinberg Gallery, Santa Monica.
"Half-Truths," Parrish Art Museum, Southampton.
"Que Overdose," Mincher/Wilcox Gallery, San Francisco.
"The Last Decade: American Artists of the 80's," Tony Shafrazi Gallery, New York.
"Culture in Pieces, Other Social Objects," Beaver College Art Gallery, Glenside.
"Meeting Place: Robert Gober, Liz Magor, Juan Munoz," The Art Gallery of York University, Toronto; Nickle Art Museum, Calgary; Vancouver Art Gallery, Vancouver.
"Blood Remembering," Newhouse Center for Contemporary Art, Staten Island.
"The Andrew Glover Youth Program Benefit Exhibition," Josh Baer Gallery, New York.
"Home," Asher Faure, Los Angeles.
"ACT UP Auction For Action," Paula Cooper Gallery, New York.

1991

"Forbidden Games," Jack Tilton Gallery, New York.
"Something Pithier and More Psychological," Simon Watson, New York.
"Whitney Biennial," Whitney Museum of American Art, New York.
"Metropolis," Martin-Gropius-Bau, Berlin.
"Object Lessons," Portland Art Museum, Portland.
"Home for June," Contemporary Theatre and Art, New York.
"Strange Abstraction," Museum of Contemporary Art Tokyo, Tokyo.
"Robert Gober, Cady Noland, Christopher Wool," Galerie Max Hetzler, Cologne.
"La Sculpture Contemporaine: Après 1970," Fondation Daniel Templon, Musée Temporaire, Fréjus.
"True to Life," 303 Gallery, New York.
"The Thing Itself," Feature, New York.
"The Lick of the Eye," Shoshana Wayne Gallery, Santa Monica.
"Objects for the Ideal Home: The Legacy of Pop Art," Serpentine Gallery, London.
"Larry Clark, Robert Gober, Mike Kelley, Jeff Koons, Cady Noland, Richard Prince, Cindy Sherman, Christopher Wool," Luhring Augustine, New York, and Hetzler, Santa Monica.
Paula Cooper Gallery, New York.
"Selections from the Elaine and Werner Dannheisser Collection: Painting and Sculpture from the 80's and 90's," Parrish Art Museum, Southampton.
"Devil on the Stairs: Looking Back on the Eighties," Institute of Contemporary Art, Philadelphia, and Newport Harbor Art Museum, Newport Beach.
"Katharina Fritsch, Robert Gober, Reinhard Mucha, Charles Ray, Rachel Whiteread," Luhring Augustine, New York.
"The Physical Self," Museum Boymans-van Beuningen, Rotterdam.
"Contemporary Collectors," San Diego Museum of Contemporary Art, La Jolla.
"ACT UP Benefit Exhibition," Matthew Marks, New York.
"ACT UP Benefit Exhibition," Paula Cooper Gallery, New York.
"American Art of the 80's," Palazzo delle Albere, Trento.

1992

"One Leading to Another," 303 Gallery, New York.
Rubin Spangle, New York.
"Allegories of Modernism: Contemporary Drawing," The Museum of Modern Art, New York.
"Doubletake: Collective Memory & Current Art," Hayward Gallery, South Bank, London.
"Marking the Decades: Prints 1960-1990," The Baltimore Museum of Art, Baltimore.
"Currents 20/Recent Narrative Sculpture," Milwaukee Art Museum, Milwaukee.
"Habeas Corpus," Stux Gallery, New York.
"The Last Days," Pabellon de Espana, Seville.
"C'est pas la fin du monde, une exposition des années 80," Le Musée d'Application, Université Rennes, Rennes.
"Chicago Expo 92," Vivian Horan Fine Art, Chicago.

"ethik und asthetik im zeitalter von aids," Kunstverein in Hamburg, Hamburg, and Kunstmuseum Luzern, Luzern.

"Zoe Leonard, Felix Gonzalez-Torres, Kiki Smith, Robert Gober," Jack Hanley Gallery, San Francisco.

"Documenta IX," Kassel, Germany.

"Post Human," FAE Musée d'Art Contemporain, Pully/Lausanne; Castello di Rivoli, Museo d'Arte Contemporanea Rivoli, Torino; Deste Foundation for Contemporary Art, Athens; Deichtorhallen Hamburg, Hamburg.

"TransForm," Kunstmuseum und Kunsthalle Basel, Basel.

"Art & the Social Conscience & Project Row Houses," Robert McClain & Co., Houston.

"This is My Body, This is My Blood," Herter Art Gallery, University of Massachusetts, Boston.

"Robert Gober, Donald Judd, Cady Noland, Rudolf Stingel," Paula Cooper Gallery, New York.

"Hair," John Michael Kohler Arts Center, Sheboygan.

"Corporal Politics," Massachusetts Institute of Technology, Cambridge.

1993
"Live in Your Head," Hochschule für Angewandte Kunst in Wein, Vienna.

"Merce Cunningham Dance Company Benefit Art Sale," 65 Thompson Street, New York.

"Zeitsprünge: Sammlung Rudolf und Ute Scharpff," Wilhelm-Hack-Museum, Ludwigshafen am Rhein.

"Saints and Survivors in a Time of Plague," Lowinsky Gallery, New York.

"Exhibition to Benefit The Robert Mapplethorpe Laboratory for AIDS Research New England Deaconess Hospital," Barbara Gladstone Gallery, New York.

"Works on Paper," Galerie Ghislaine Hussenot, Paris.

"Works on Paper," Paula Cooper Gallery, New York.

"Whitney Biennial," Whitney Museum of American Art, New York.

"Zeichnungen Setzen Zeichzen: 44 Kunstler der Documenta IX: Arbeiten auf Papier," Galerie Raymond Bollag, Zurich.

"Gober, Kelly, Kippenberger, Koons, Sherman, Wool," Galerie Schurr, Stuttgart.

"20 Years: A Series of Anniversary Exhibitions, Part I," Daniel Weinberg Gallery, Santa Monica.

"Prints and Issues," Kunst-Werke, Berlin.

"De la main à la tête, l'objet théorique," Domaine de Kerguehennec, Bignan.

"Body Parts," Haines Gallery, San Francisco.

"American Art in the 20th Century," Martin-Gropius-Bau, Berlin, and Royal Academy of Arts, London.

"Fall From Fashion," The Aldrich Museum of Contemporary Art, Ridgefield.

"Robert Gober, Zoe Leonard,...," Fawbush, New York.

"Abject Art: Repulsion and Desire in American Art," Whitney Independent Study Program, Whitney Museum of American Art, New York.

"The Sublime Void: An Exhibition on the Memory of the Imagination," Royal Museum of Fine Arts, Brussels.

"Sculptors and Paper," Hiram Butler Gallery, Houston.

"Recent Editions: Prints and Illustrated Books," Susan Sheehan Gallery, New York.

"New Moderns," Baumgarter Galleries, Inc., Washington, D.C..

"Empty Dress: Clothing as Surrogate in Recent Art," ICI, New York.

"Recent Acquisitions in the Permanent Collection," The Museum of Contemporary Art, Los Angeles.

"The Return of the Cadavre Exquis," The Drawing Center, New York; The Corcoran Gallery of Art, Washington D.C.; Foundation for Contemporary Art, Mexico City; Santa Monica Museum, Santa Monica; The Forum, St. Louis.

"Extra-Ordinary," I.C. Editions/Printed Matter, New York.

"25 Years (Part II)," Paula Cooper Gallery, New York.

1994
"Desire and Loss," Carl Solway Gallery, Cincinnati.

"Don't Look Now," Thread Waxing Space, New York.

"Change of Scene V," Museum für Moderne Kunst, Frankfurt am Main.

"The Use of Pleasure," Terrain Gallery, San Francisco.

"The Ossuary," Luhring Augustine Gallery, New York.

"A Garden," Barbara Krakow Gallery, Boston.

"Drawings: Reaffirming the Media," University of Missouri-Kansas City Gallery of Art, Kansas City.

"Interiors: Some Work from the Permanent Collection," The Museum of Contemporary Art, Los Angeles.

"Gift," The InterArt Center, New York.

"30 Years," The Aldrich Museum of Contemporary Art, Ridgefield.

"Zimmer in denen die Zeit nicht zahlt: Die Sammlung Udo und Anette Brandhorst," Museum für Gegenwartskunst, Basel.

"Oh boy, it's a girl!," Kunstverein München, Munich.

"Tuning Up #2," Kunstmuseum Wolfsburg, Wolfsburg.

"Transmitting Truth: Reformulating News Media Information," School of The Art Institute of Chicago, Betty Rymer Gallery, Chicago.

Galerie Samia Saouma, Paris.

"Guys Who Sew," University Art Museum, University of California, Santa Barbara.

"Duchamp's Leg," Walker Art Center, Minneapolis.

"Artists' Books," Paula Cooper Gallery, New York.

"Holiday Exhibition," Paula Cooper Gallery, New York.

1995
"Silent & Violent: Selected Artists' Editions," MAK Center for Art and Architecture, Los Angeles.

"In a Different Light," University Art Museum, University of California, Berkeley.

"Sex," Greg Kucera Gallery, Seattle.

"Ars 95 Helsinki," Museum of Contemporary Art/Finnish National Gallery, Helsinki.

"Fashion is a Verb," The Museum at the Fashion Institute of Technology, New York.

"Micromegas: Miniatures and Monstrosities," American Center, Paris, and The Israel Museum, Jerusalem.

Daniel Weinberg Gallery, San Francisco.

"Altered States: American Art in the 90's," Forum for Contemporary Art, St. Louis.

"L'Immagine Riflessa: Una selezione di fotografia contemporanea dalla collezione LAC, Svizzera," Museo Pecci, Prato.

"Recent Acquisitions: American Friends of the Israel Museum," Marian Goodman Gallery, New York.

"Sculpture as Objects," Curt Marcus Gallery, New York.

"Face Foward: Self-Portraiture in Contemporary Art," John Michael Kohler Arts Center, Sheboygan.

"Into a New Museum: Recent Gifts and Acquisitions, Part 2," San Francisco Museum of Modern Art, San Francisco.

"Rites of Passage: Art for the End of the Century," Tate Gallery, London.

"Sleeper: Katharina Fritsch, Robert Gober, Guillermo Kuitca, Doris Salcedo," San Diego Museum of Contemporary Art, La Jolla.

"Contemporary Drawing: Exploring the Territory," Aspen Art Museum, Aspen.

"Economies of Scale," The Museum of Contemporary Art, Los Angeles.

"Altered and Irrational: Selections from the Permanent Collection," Whitney Museum of American Art, New York.

"Feminin/masculin: le sexe de l'art," Centre Georges Pompidou, Paris.

"Signs & Wonders," Kunsthaus, Zurich, and Centro Galego de Arte Contemporanea, Santiago de Compostela.

"The Carnegie International 1995," The Carnegie Museum of Art, Pittsburgh.

"Das Américas," Museo de Arte de Sao Paulo, Sao Paulo.

"Faculty Work on Paper," Yale University, New Haven.

"Prints: To Benefit the Foundation for the Contemporary Performance Arts," Brooke Alexander Gallery, New York.

"A Glimpse of the Norton Collection as Revealed by Kim Dingle," Santa Monica Museum of Art, Santa Monica.

1996
Musée d'Art Contemporain, Nîmes.

"Everything that's Interesting is New: The Dakis Joannou Collection," School of Fine Arts, Athens.

"The Human Body in Contemporary Sculpture," Gagosian Gallery, New York.

"Handmade Readymades," Hunter College, New York.

"Model Home," Institute for Contemporary Art, Clocktower Gallery, New York.

"Legende I," Museet fur Samtids Kunst, Roskilde.

"Deformations: Aspects of the Modern Grotesque," The Museum of Modern Art, New York.

"Continuity and Contradiction: A New Look at the Permanent Collection," San Diego Museum of Contemporary Art, La Jolla.

"Nudo & Crudo," Claudia Gian Ferreti Arte Contemporanea, Milan.

"Permanent Collection," San Francisco Museum of Modern Art, San Francisco.

"Dissonant Wounds: Zones of Display/Metaphors of Atrophy," Center for Curatorial Studies and Art in Contemporary Culture, Bard College, Annandale-on-Hudson.

"A Century of American Drawing: From the Collection," The Museum of Modern
 Art, New York.
"Say it with flowers," Galerie Chantal Crousel, Paris.
"Szenenwechsel X," Museum für Modern Kunst, Frankfurt am Main.
"Distemper: Dissonant Themes in the Art of the 1990s," Hirshhorn Museum and
 Sculpture Garden, Washington, D.C..
"Thinking Print: Books to Billboards 1980-95," The Museum of Modern Art,
 New York.
"Magritte," Musée des Beaux-Arts, Montréal.
"Sculpture," Galerie Hauser & Wirth, Zurich.
"From Figure to Object: A Century of Sculptors' Drawings," Karsten Schubert
 and Frith Street Gallery, London.
"Wandering About in the Future: New Tate Acquisitions," Tate Gallery,
 Liverpool.
"Avant-première d'un musée - Le Musée d'Art Contemporain de Gand,"
 Institut Néerlandais, Paris.
"Playpen & Corpus Delirium," Kunsthalle Zurich, Zurich.
"Views from Abroad 2: European Perspectives on American Art 2," Whitney
 Museum of American Art, New York, and Museum für Moderne Kunst,
 Frankfurt am Main.
"{Open Secrets} Seventy Pictures on Paper: 1815 to the Present," Matthew Marks
 Gallery, New York, and Fraenkel Gallery, San Francisco.
"René Magritte: Die Kunst der Konversation," Kunstsammlung Nordrhein-
 Westfalen, Dusseldorf.
"Try a Little Tenderness," APEX Art, New York.
Paula Cooper Gallery, New York.
"30th Anniversary Temple University Rome Program Exhibition," Temple
 Gallery, Temple University, Philadelphia.

1997
"This End Up: Selections from the Robert J. Shiffler Collection," Cleveland
Center for Contemporary Art, Cleveland.
"De-Genderism," Setagaya Art Museum, Tokyo.
"Die Sammlung Scharpff in der Hamburger Kunsthalle," Galerie der Gegenwart,
 Hamburg.
"Recent Photographic Acquisitions," The Museum of Modern Art, New York.
"Veronica's Revenge: Oeuvres photographiques de la Lambert Art Collection,"
 Centre d'Art Contemporain, Geneva.
"Sous le manteau," Galerie Thaddaeus Ropac, Paris.
"Wood Not Wood/Work Not Work," A/D, New York.
"Inside," Henry Art Gallery, University of Washington, Permanent exhibition of
 the Collection Ackerman, Museum Kurhaus Kleve, Kleve.
"Gothic," Institute of Contemporary Art, Boston, and Portland Art Museum,
 Portland.
"The Compulsion to Remember," Center for Curatorial Studies Museum,
 Bard College, Annandale-on-Hudson.
"Broken Home," Greene Naftali Gallery, New York.
"The Age of Modernism: Art in the 20th Century," Martin-Gropius-Bau, Berlin.
"Apocalyptic Wallpaper: Robert Gober, Abigail Lane, Virgil Marti & Andy
 Warhol," Wexner Center for the Arts, Columbus.
"Objects of Desire: The Modern Still Life," The Museum of Modern Art,
 New York, and Hayward Gallery, London.
"Check in," Museum für Gegenwartskunst, Basel.

Selected Bibliography

Exhibition Catalogues

1989 Biennial Exhibition. (New York: Whitney Museum of American Art, 1989), 52-55.

1991 Biennial Exhibition. (New York: Whitney Museum of American Art, 1991), 82-85.

Album. (Rotterdam: The Photographic Collection of Museum Boymans-van Beuningen, 1995), 209-211.

American Art of the 80s. (Trento: Palazzo delle Albere, 1991), 51, 120-121.

The Binational: American Art of the Late 80s. (Cologne: Dumont Buchverlag, and Boston: The Institute of Contemporary Art and Museum of Fine Arts, 1988), 91-94.

Blurring the Boundaries: Installation Art 1969-1996. (La Jolla: Museum of Contemporary Art, San Diego, and New York: D.A.P., 1997), 24, 44-45.

Oh boy, it's a girl. (Munich: Kunstverein München, 1994).

Carnegie International 1995. (Pittsburgh: Carnegie Museum of Art, 1995), 86-89.

Cultural Geometry. (Athens: Deste Foundation for Contemporary Art, 1988).

Culture and Commentary: An Eighties Sculpture. (Washington, D.C.: Hirshhorn Museum and Sculpture Garden, 1990), 62-67.

DASAMÉRICAS. (São Paulo: Museo de Arte de São Paulo, 1995).

De-Genderism. (Tokyo: Setagaya Art Museum, 1997), 22, 98-103.

Don't Look Now. (New York: Thread Waxing Space, 1994).

Doubletake: Collective Memory & Current Art. (London: The Southbank Centre, 1992), 144-147, 212, 222-223.

ethik und asthetik im zeitalter von aids. (Hamburg: Kunstverein in Hamburg, 1992), 18-21.

Everything That's Interesting Is New: The Dakis Joannou Collection. (Athens: Deste Foundation for Contemporary Art, and Stuttgart: Cantz, 1996), 110-118.

Family Values: American Art in the Eighties and Nineties. (Hamburg: The Scharpff Collection at the Hamburg Kunsthalle, Hamburger Kunsthalle, 1997), 22-31.

Fémininmasculin. Petit journal de l'exposition. (Paris: Centre Georges Pompidou, 1996).

Robert Gober. (Rotterdam: Museum Boymans van-Beuningen, 1990). Essays by Ulrich Loock, Karel Schampers, and Trevor Fairbrother.

Robert Gober. (London: Serpentine Gallery, and Liverpool: Tate Gallery, 1993).

Robert Gober. (Umag: Galerija Dante Marino Cettina, 1995).

Gober, Halley, Kessler, Wool: Four Artists from New York. (Munich: Kunstverein München, 1989), 8, 12, 18-31.

Horn of Plenty. (Amsterdam: Stedelijk Museum, 1989), 11, 26, 37, 45, 57, 72.

Hybrid Neutral: Modes of Abstraction and the Social. (Denton: The University of North Texas Art Gallery, 1988).

René Magritte: Die Kunst der Konversation. (Dusseldorf: Kunstsammlung Nordrhein-Westfalen, 1996), 223-225.

Nudo & Crudo. (Milan: Claudia Gian Ferreti Arte Contemporanea, 1996), 34-35.

{Open Secrets} Seventy Pictures on Paper: 1815 to the Present. (New York: Matthew Marks Gallery, and San Francisco: Fraenkel Gallery, 1996).

Passion Privées: Collections Particulières d'Art Moderne et Contemporain en France. (Paris: Musée d'art Moderne de la Ville de Paris, and Paris: Paris-Musées, 1995).

The Physical Self. (Rotterdam: Museum Boymans-van Beuningen, 1992), 85.

Playpen & Corpus Delirium. (Zurich: Kunsthalle Zurich, 1996), 3, 22-23, 26.

Pleasures and Terrors of Domestic Comfort. (New York: The Museum of Modern Art, 1991), 19-20. Introduction by Peter Galassi.

Psychological Abstraction. (Athens: Deste Foundation for Contemporary Art, 1989).

The Readymade Boomerang: Certain Relations in 20th Century Art. (Sydney: The Eighth Bienalle of Sydney, Art Gallery of New South Wales, 1990), 402-403.

Rites of Passage: Art for the End of the Century. (London: Tate Gallery, 1995).

Sculpture: Inside Outside. (Minneapolis: Walker Art Center, 1988), 96-105.

Signs & Wonders. (Zurich: Kunsthaus Zurich, 1995), 118-119.

Utopia Post Utopia. (Boston: The Institute of Contemporary Art, 1988), 18-26, 53-57, 60-65, 100-102.

Zimmer in denen die Zeit nicht zahlt: Die Sammlung Udo und Anette Brandhorst. (Basel: The Musuem für Gegenwartskunst, 1994), 123-128.

Ammann, Jean-Christophe, and Adam Weinberg. *Views from Abroad: European Perspectives on American Art 2.* (New York: Whitney Museum of American Art, 1996), 133.

Benezra, Neal. *Robert Gober.* (Chicago: The Art Institute of Chicago, 1988).

Benezra, Neal, and Olga M. Viso. *Distemper: Dissonant Themes in the Art of the 1990s.* (Washington, D.C.: Hirshhorn Museum and Sculpture Garden, Smithsonian Institution, and New York: D.A.P., 1996), viii, 40-47, 118-119.

Blake, Nayland, Lawrence Rinder, and Amy Scholder. *In a Different Light.* (Berkeley: University Art Museum, Univiersity of California, Berkeley, 1995), 34, 56.

Brown, Elizabeth A., and Fran Seegull. *Guys Who Sew.* (Santa Barbara: University Art Museum, University of California, Santa Barbara, 1994), 7, 8, 14.

Cameron, Dan. *Art and Its Double: A New York Perspective.* (Barcelona: Centre Cultural de La Fundacio Caixa de Pensiones, 1987), 54-57.

———. *NY Art Now: The Saatchi Collection.* (London: The Saatchi Collection, 1987), 91-98.

———. "When is a door not a door?," in *La Biennale di Venezia XLIII*. (Venice: Edizione La Biennale, 1988), 309-312.

Collins, Tricia, and Richard Milazzo. *Art at the End of the Social*. (Malmö: Rooseum, 1988), 293-299.

Colombo, Paolo. *Robert Gober*. (Elkins Park: Tyler School of Art, Temple University, 1988).

Deitch, Jeffrey. *Strange Abstraction*. (Tokyo: Museum of Contemporary Art Tokyo, 1991).

Hickey, Dave. *Robert Gober*. (New York: Dia Center for the Arts, 1992). Introduction by Karen Marta.

Indiana, Gary. *A Project: Robert Gober and Christopher Wool*. (New York: 303 Gallery, 1988).

Joachimedes, Christos, and Norman Rosenthal. *Metropolis*. (Berlin: Martin-Gropius-Bau, 1991), 137-139, 286.

Joachimedes, Christos, and Norman Rosenthal, ed. *American Art in the 20th Century: Painting and Sculpture, 1913-1993*. (Berlin: Martin-Gropius-Bau, and London: The Royal Academy of Fine Arts, 1993), 20, 140, 141, 194, 251, 448.

Nickas, Robert. *Live In Your Head*. (Vienna: Hochschule Für Angewandte Kunst In Wein, 1993).

Noever, Peter. *Silent & Violent: Selected Artists' Editions*. (Los Angeles: MAK-Center for Art and Architecture Los Angeles, and Stuttgart: Parkett Verlag and Cantz, 1997).

Rose, Bernice. *Allegories of Modernism: Contemporary Drawing*. (New York: The Museum of Modern Art, 1992), 103.

Saltz, Jerry. *Beyond Boundaries, New York's New Art*. (New York: A. Van der Marck Editions, 1986), 45-47. Essays by Roberta Smith and Peter Halley.

Schimmel, Paul, and Kenneth Baker. *Objectives: The New Sculpture*. (Newport Beach: Newport Harbor Art Museum, 1990), 66-81.

Simon, Joan. *Robert Gober*. (Paris: Galerie Nationale du Jeu de Paume, and Madrid: Museo Nacional Centro de Arte Reina Sofía, 1991).

Simon, Joan, and Roberta Smith. *Abstraction in Question*. (Sarasota: The John and Mable Ringling Museum of Art, 1989), 14, 46, 47.

Sobel, Dean. *Recent Narrative Sculpture*. (Milwaukee: Milwaukee Art Museum, 1992).

Storr, Robert. *Devil on the Stairs: Looking Back on the Eighties*. (Philadelphia: Institute of Contemporary Art, 1992).

Vischer, Theodora. *Robert Gober*. (Basel: Museum für Gegenwartskunst, 1995).

Weaver, Thomas. *Handmade Readymades*. (New York: Hunter College, 1996), 6.

Weber, John. *Object Lessons*. (Portland: Portland Art Museum, 1991), 10-11.

Wye, Deborah. *Thinking Print: Books to Billboards, 1980-95*. (New York: The Museum of Modern Art, 1996).

Books

Caldwell, John. *This is about who we are: The Collected Writings of John Caldwell*. Thea Westreich, ed. (San Francisco: San Francisco Museum of Modern Art, 1996), 126-135, 202.

Foster, Hal. *The Return of the Real*. (Cambridge: The MIT Press, 1996), 25, 152, 154, 155.

Gotz, Stephen. *American Artists In Their New York Studios: Conversations About the Creation of Contemporary Art*. (Cambridge: Harvard University Art Museums, Center for Conversation and Technical Studies, and Stuttgart: Daco-Verlag Gunter Blase, 1992), 63-66.

Jameson, Frederic. *Postmodernism or, The Cultural Logic of Late Capitalism*. (Durham: Duke University Press, 1991), 161-172.

Oliveira, Oxley and Petry. *Installation Art*. (London: Thames and Hudson, 1994), 132-133.

Sanders, Joel, ed. *Stud: Architectures of Masculinity*. (Princeton: Princeton Architectural Press, 1996), 20, 174-179, 309, 312.

Sherlock, Maureen P. "Decoy: Displacements of Loss and Hope" in Lynne Cooke, and Karen Kelly, eds. *Robert Lehman Lectures on Contemporary Art*. (New York: Dia Center for the Arts, 1996), 107-127.

Periodicals

"Gober? Comment cherie tu ne connais pas cet artiste?" *Actuel* (November 1991).

"Robert Gober," *Bijutsu Techo* (Japan) (January 1995): 46-49.

"Robert Gober at the Kunsthalle," *Flash Art*, no. 154 (October 1990): 173.

"Robert Gober at Museum für Gegenwartskunst," *Flash Art* 29, no. 186 (January/February 1996): 41.

"Robert Gober in Rotterdam," *Flash Art*, no. 152 (May/June 1990): 173.

"Was it Just A Dream?" *Print Collector's Newsletter* (November/December 1989): 175.

"X-Rated Wallpaper," *BLK* (May 1990): 3.

Adams, Brooks. "Artschwager et Gober: D'étranges cousins," *Artstudio*, no. 19 (Winter 1990): 64-77.

Aliaga, Juan Vicente. "Coming and Going," *frieze* 27 (March/April 1996): 58-59.

Allthorpe-Guyton, Marjorie. "NY Art Now: The Saatchi Collection. London," *Flash Art*, no. 137 (November/December 1987): 109.

Amman, Jean-Christophe. "New York: Robert Gober in de Dia Foundation," *Kunst-Bulletin* (January/February 1993): 48-50.

Atkins, Robert. "Very Queer Indeed," *Village Voice* (January 31, 1995).

Aukeman, Anastasia. "Robert Gober," *Artnews* 93 (November 1994): 154.

Avgikos, Jan. "Tell Them It Was Wonderful," *Artscribe*, no. 80 (March/April 1990): 66-69.

Bonami, Francesco. "Spotlight," *Flash Art*, no. 168 (January/February 1993): 86-87.

Bordowitz, Gregg. "Against Heterosexuality," *Parkett*, no. 27 (March 1991): 100-11.

———. "Who is Art?" *Outweek* (October 22, 1989): 56, 63.

Bourriaud, Nicolas. "Figuration in an Age of Violence," *Flash Art* 25, no. 162 (January/February 1992): 87-91.

———. "Slits," *Documents* 1 (October 1992): 30-37.

———. "Spotlight: Robert Gober," *Flash Art* 25, no. 162 (January/February 1992): 123.

Buck, Louisa. "Out on a Limb," *GQ* (April 1993).

Cameron, Dan. "Robert Gober," *Galeries Magazine* 45 (October/November 1991): 92-97, 156.

Campitelli, Maria. "Robert Gober," *Juliet*, no. 39 (December 1988/January 1989): 35.

Cappuccio, Elio. "The Work and Its Aura," *Tema Celeste*, no. 24 (January-March 1990): 34-35.

Collins, Tricia, and Richard Milazzo. "Post Appropriation and the Romantic Fallacy: Gober, Etkin, Shaver and Carrol," *Tema Celeste*, no. 21 (July-September 1989): 36-43.

———. "Robert Gober: The Subliminal Function of Sinks," *Kunstforum*, no. 84 (June/August 1986): 320-322.

Cone, Michele. "Ready-Mades on the Couch," *Artscribe* (June/July 1986): 30-33.

Conrads, Martin. "Alptraum der Pubertèt: 'Boy Coming out of Man': Robert Gober in der Galerie Max Hetzler," *zitty* (June 1996): 89.

Cookc, Lynnc. "Micromegas," *Parkett*, no. 44 (July 1995): 132-145.

———. "Venice Biennale: aperto ma non troppo," *Art International*, no. 4 (Autumn 1988): 60-62.

Cottingham, Laura. "The Pleasure Principled," *Frieze* 10 (May 1993): 10-15.

Danto, Arthur C. "Art for Activism's Sake," *The Nation* (June 3, 1991): 743-747.

Decter, Joshua. "Robert Gober," *Arts Magazine* 60, no. 4 (December 1985): 124.

Deitch, Jeffery. "Psychological Abstraction," *Flash Art*, no. 149 (November/December 1989): 164-165.

Dormant, Richard. "A Vile Talent to Disturb," *The Daily Telegraph* (March 17, 1993): 22.

Drobnick, Jim. "In Pieces, of Pieces: Robert Gober," *Parachute* 64 (October-December 1991): 13-17.

Evans, Steven. "Robert Gober/Christopher Wool," *Artscribe International*, no. 72 (November/December 1988): 80.

Faust, Gretchen. "Robert Gober, Donald Judd, Cady Noland, Rudolf Stingel," *Forum International* (March/April 1993): 122.

Feaver, William. "Of Couples and Their Cat Litter," *The Observer* (March 1993).

Felshin, Nina. "Clothing as Subject," *Art Journal* 54 (Spring 1995): 20-29.

FitzGerald, Michael. "Straight from the Source," *Vogue* (May 1996): 294-301.

Flood, Richard. "Real Life Rock, Top Ten - No. 1 Robert Gober," *Artforum* 34, no. 6 (February 1996): 24.

———. "Robert Gober: Special Editions, An Interview," *Print Collector's Newsletter* 21 (March/April 1990): 6-9.

Foster, Hal. "Obscene, Abject, Traumatic," *October* 78, (Fall 1996): 106-124.

———. "What's Neo about the Neo-Avant Garde?" *October* 70 (Fall 1994): 5-32.

François, Alain-Henri. "Robert Gober," *Voir* (December 1991-January 1992): 25.

Gerstler, Amy. "Fancy Work," *Art Issues*, no. 10 (March/April 1990): 17-20.

Gholson, Craig. "Robert Gober," *Bomb*, no. 29 (Fall 1989): 32-37.

Gillick, Liam. "Doubletake," *Art Monthly* (March 1992): 14-15.

Glueck, Grace. "Dia's Freudian Dreamscape; Conceptual Triple Threat," *The New York Observer* (October 19, 1992): 19.

Gober, Robert. *Journal of Contemporary Art* 1, no. 2 (Fall/Winter 1988): 17-23.

———. "Cumulus," *Parkett*, no. 19 (March 1989): 169-171.

———. "Edition for Parkett," *Parkett*, no. 27 (March 1991): 78.

———. "Hanging Man: A Conversation Between T. Bush, R. Gober, N. Rifkin," *Parkett*, no. 27 (March 1991): 90-97.

———. "Profiles & Positions/Gran Fury," *Bomb*, no. 34 (Winter 1991): 8-13.

———. "Six Drawings," *The Paris Review* 30, no. 109 (Winter 1988): 81-87.

Graber, Hedy. "Installations: Robert Gober," *Voir: Le Magazine des Arts*, no. 120 (December 1995): 4.

Graham-Dixon, Andrew. "Dismembered Vision," *The Independent* (March 3, 1992): 85.

———. "Home is Where the Heart is Broken," British *Vogue* (January 1992): 106-107, 143.

Halle, Howard. "Ready or Not," *Time Out* (New York) (February 1996): 24.

Heartney, Eleanor. "The Expanded Readymade," *Art in America* 78, no. 9 (September 1990): 88-95.

———. "Homeward Unbound," *Sculpture* (September/October 1989): 20-23.

———. "Robert Gober: Une Sculpture du Deracinement," *Artpress* (April 1990): 36-39.

Helfenstein, Josef. "The Power of Intimacy," *Parkett*, no. 27 (March 1991): 28-36.

Hess, Elizabeth. "Paradise Lost," *The Village Voice* (October 20, 1992): 87.

Hickey, Dave. "Straight Talk," *Art & Text*, no. 53 (January 1996): 40-41.

Hoet, Jan. "1992 Documenta: Museum of Feelings," *Edges* 3, no. 3 (December 1990): 8-14.

Indiana, Gary. "Success: Robert Gober," *Interview* (May 1990): 72.

———. "The Torture Garden," *The Village Voice* 32, no. 43 (October 27, 1987): 105.

Janus, Elizabeth. "Robert Gober," *Tema Celeste*, no. 30 (March/April 1991): 100-101.

Jones, Ronald. "Robert Gober," *frieze* 18 (September/October 1994): 70-71.

Joselit, David. "Investigating the Ordinary," *Art in America* 76 (May 1988): 148-154.

Juarez, Roberto. "Selected Similarities," *Bomb*, no. 18 (Winter 1987): 84-95.

Kachur, Lewis. "Sculpture's Unbound Range," *Art International*, no. 8 (Autumn 1989): 57-59.

Kalina, Richard. "Real Dead," *Arts Magazine* 66 (December 1991): 50-51.

Kazanjian, Dodie. "Artist at Odds," *Vogue* (February 1993): 226-32.

Kent, Sarah. "Un-American Dreams," *Time Out* (March 17-24, 1993): 18-19.

Kirk, John T. "An Awareness of Perfection," *Design Quarterly*, no. 154 (Winter 1992): 14-19.

Koether, Jutta. "Robert Gober," *Artforum* 27 (February 1989): 145.

Kuspit, Donald. "Breakfast of Duchampians," *Contemporanea* 2, no. 3 (May 1989): 68-73.

———. "The Decline, Fall and Magical Resurrection of the Body," *Sculpture* 13, no. 3 (May-June 1994): 20-23.

———. "The End of the World Has Already Happened: Robert Gober," *Artforum* 31 (February 1993): 91-93.

Labaume, Vincent. "L'avenir d'une promotion: le corps," *Artpress*, no. 175 (1992): 32-33.

Larson, Philip. "Urinals of the World Unite: Duchamp's Leg Will Stand Up for You," *PCN* (January/February 1995): 211-215.

Lebovici, Elisabeth. "Robert Gober, fragments faits main," *Liberation* (9 October 1991).

Leigh, Christian. "Home is Where the Heart is," *Flash Art*, no. 145 (March/April 1989): 74-83.

———. "Into the Blue," *Art & Auction* 11, no. 10 (May 1989): 262-269.

Lewis, James. "Home Boys," *Artforum* 30 (October 1991): 101-105.

Lewis, Katherine. "NEA Watch/Radice to Decency's Rescue," *Artpaper* 11, no. 10 (Summer 1992): 9.

Liebman, Lisa. "The Case of Robert Gober," *Parkett*, no. 21 (September 1989): 6-9.

Llorca, Pablo. "Robert Gober inaugra la nueva galeria madrilena de Marga Paz," *Diario* 16 (November 24, 1990): 1, 52.

MacAdam, Barbara. "'Anyone Who Doesn't Change His Mind Doesn't Have One'," *Art News* 92 (November 1993): 144-149.

Madoff, Steven Henry. "Sculpture, A New Golden Age?," *Artnews* 90 (May 1991): 100-121.

Mahoney, Robert. "Real Inventions/Invented Functions," *Arts Magazine* (May 1988): 102.

———. "Robert Gober, Dia Center for the Arts, New York," *Sculpture* 12, no. 1 (January/February 1993): 68.

Marincola, Paula. "Robert Gober, Tyler School of Art Gallery," *Artforum* 26 (May 1988): 153.

Messler, Norbert. "Robert Gober at the Museum Boymans-van Beuningen," *Artforum* 29 (November 1990): 182-183.

Morgan, Stuart. "Le Corps en Morceaux," *Beaux Arts*, no. 102 (1992): 46.

Muracciole, Marie. "Robert Gober, Primer Americano En El Nuevo de Paume," *El Guia* (October/November 1991): 81-82.

Myers, Terry. "Robert Gober, Donald Judd, Cady Noland, Rudolf Stingel," *Lapiz* (March/April 1993): 68-69.

Pamici, Odinea. "Robert Gober," *Juliet* (April/May 1995): 56.

Perchuk, Andrew. "Robert Gober at Paula Cooper Gallery," *Artforum* 33 (October 1994): 101.

Pincus-Witten, Robert. "Entries: Electrostatic Cling or the Massacre of Innocence," *Artscribe* (Summer 1987): 1, 36-41.

Portes, Florence. "Pierre Dunoyer et Robert Gober," *Le Match de Paris* (28 November 1991).

Princenthal, Nancy. "Robert Gober at Paula Cooper," *Art in America* 75 (December 1987): 153-154.

———. "Rooms with a View," *Sculpture* (March/April 1990): 28.

Puvogel, Renate. "Robert Gober at Galerie Hetzler, Galerie Gisela Capitain," *Artscribe International*, no. 75 (May 1989): 88-89.

Reust, Hans Rudolf. "Robert Gober," *Artscribe*, no. 85 (January/February 1991): 93-94.

Rian, Jeff. "What's All This Body Art?," *Flash Art*, no. 168 (January/February 1993): 50-53.

Rinder, Larry. "Kevin Larmon and Robert Gober," *Flash Art*, no. 128 (May/June 1986): 56-57.

Rubinstein, Meyer Raphael, and Daniel Weiner. "Spotlight: Robert Gober," *Flash Art*, no. 138 (January/February 1988): 119.

Saltz, Jerry. "Notes on a sculpture," *Arts Magazine* 64, no. 4 (December 1989): 22.

———. "Strange Fruit," *Arts Magazine* 65 (September 1990): 25-26.

Schenker, Christoph. "Robert Gober, Museum Boymans-van Beuningen, Kunsthalle Bern," *Flash Art*, no. 156 (January/February 1991): 141-142.

Schorr, Collier. "Lockdown," *Artforum* 31 (February 1993): 89-90.

Schwartz, Henry. "Robert Gober: The Remorse of Conscience," *Flash Art*, no. 177 (Summer 1994): 95-97.

Sherlock, Maureen P. "Arcadian Elegy: The Art of Robert Gober," *Arts Magazine* 64 (September 1989): 44-49.

Siegel, Jeanne. "Unveiling the Male Body," *Art Press* (September 1993): E12-E15.

Simon, Joan. "Robert Gober: Oeuvres Nouvelles," *Art Press* 162 (October 1991): 38-42.

Smith, Nancy. "Empty Dress, Loaded Images," *Ms. Magazine* (November/December 1993): 81.

Smith, Roberta. "The Reinvented Americana of Robert Gober's Mind," *The New York Times* (October 13, 1989): C28.

Smulders, Caroline. "Le corps en miettes de Robert Gober," *Beaux Arts*, no. 95 (November 1991).

Spector, Nancy. "Robert Gober: Homeward-Bound," *Parkett*, no. 27 (March 1991): 80-89.

Sundell, Margret. "Robert Gober," *Seven Days* (October 18, 1989): 73.

Taylor, Paul. "Spotlight: Cultural Geometry," *Flash Art*, no. 140 (May/June 1988): 124-125.

Troncy, Eric. "Paris Switch Points/Robert Gober Jeu de Paume," *Artscribe*, no. 90 (February/March 1992): 86.

Van der Haak, Bregtje. "Robert Gober," *Metropolis M* (February 1993): 46.

Wallach, Amei. "The Secret of Childhood," *New York Newsday* (January 13, 1991): 11, 21.

Yau, John. "Official Policy," *Arts Magazine* 64 (September 1989): 50-54.

I would like to thank the entire staff of the museum from Richard Koshalek to every member of the crew for making possible an exhibition that most other institutions would find impossible to realize. In particular, I would like to thank Paul Schimmel, who gave me the opportunity and guided the project through; his assistant Diane Aldrich; John Bowsher, who oversaw the physical installation with unflappable calm; and the publications team, Russell Ferguson, Stephanie Emerson, and the wonderful designer Catherine Lorenz, for this book.

I would also like to thank all of the talented people in New York who helped to make real what I had imagined, especially Daphne Fitzpatrick, Claudia Carson, Suzanne Wright, Sam Gordon, Bonnie Collura, James Sadek, Russell Kaye, and Jennifer Tipton. Also Donald Moffett for his enthusiasm and good advice.

—Robert Gober

This publication accompanies the exhibition "Robert Gober," organized by
Paul Schimmel and presented at The Museum of Contemporary Art, Los
Angeles, The Geffen Contemporary at MOCA, September 7 - December 14, 1997.

"Robert Gober," has been made possible in part by the generous support of
The Audrey and Sydney Irmas Charitable Foundation, Lannan Foundation,
Ruth and Jake Bloom, Douglas S. Cramer; and by Paul Randall and Cormac
O'Herlihy, Jon Douglas Company, Malibu.

Editor: Russell Ferguson
Assistant Editor: Stephanie Emerson
Designer: Catherine Lorenz
Printed by Lithographix, Inc.
Bound by Roswell Book Binding

Photo credits:
Photos pages 6-37 by Claudia Carson, Bonnie Collura, Daphne Fitzpatrick,
Lawrence Gleeson, Robert Gober, Sam Gordon, James Sadek, and Suzanne
Wright. Cover, endsheets, pages 46, 48, 54, 70-91: Russell Kaye. Pages 43, 66: D.
James Dee. Pages 47, 49 (Drain), 64: Geoffrey Clements. Page 47: Scala/Art
Resource, NY. Page 50 (Cigar): Paula Goldman. Page 51: Pierpont Morgan
Library/Art Resource, NY. Page 57: Michael Biondo. Pages 58, 59, 61, 63: K.
Ignatiadis. Page 65: Graydon Wood.

Copublished by The Museum of Contemporary Art, Los Angeles, and
Scalo Verlag, Zurich.

Copyright © 1997 The Museum of Contemporary Art, Los Angeles
250 South Grand Avenue, Los Angeles, California 90012

ISBN 0-914357-51-4 (MOCA)
ISBN 3-931141-72-1 (SCALO)

Book Shops:
Distributed in North America by D.A.P., New York City; in Europe and Asia
by Thames and Hudson, London; in Germany, Austria and Switzerland by
Scalo, Zurich.

Library of Congress Cataloguing-in-Publication Data
Schimmel, Paul.
 Robert Gober / Paul Schimmel.
 p. cm.
 Accompanies the exhibition "Robert Gober" organized by
Paul Schimmel and held at The Museum of Contemporary Art, Los Angeles,
Sept. 7–Dec. 14, 1997.
 Includes bibliographical references.
 ISBN 0-914357-51-4
 1. Gober, Robert, 1954– –Exhibitions. 2. Installations (art)–
Exhibitions. I. Museum of Contemporary Art (Los Angeles, Calif.) II. Title..
N6537.G56A4 1997
779'.2—dc21
97-27829

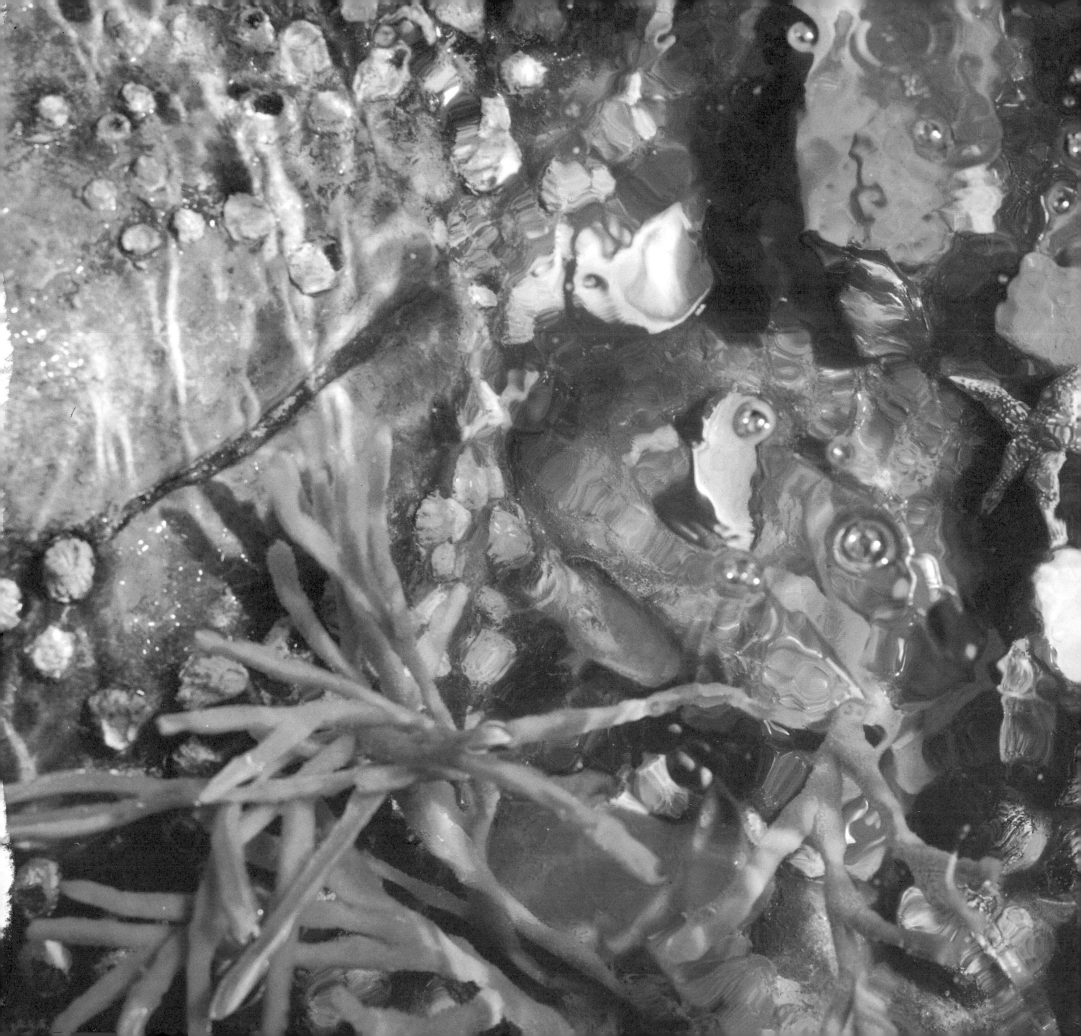

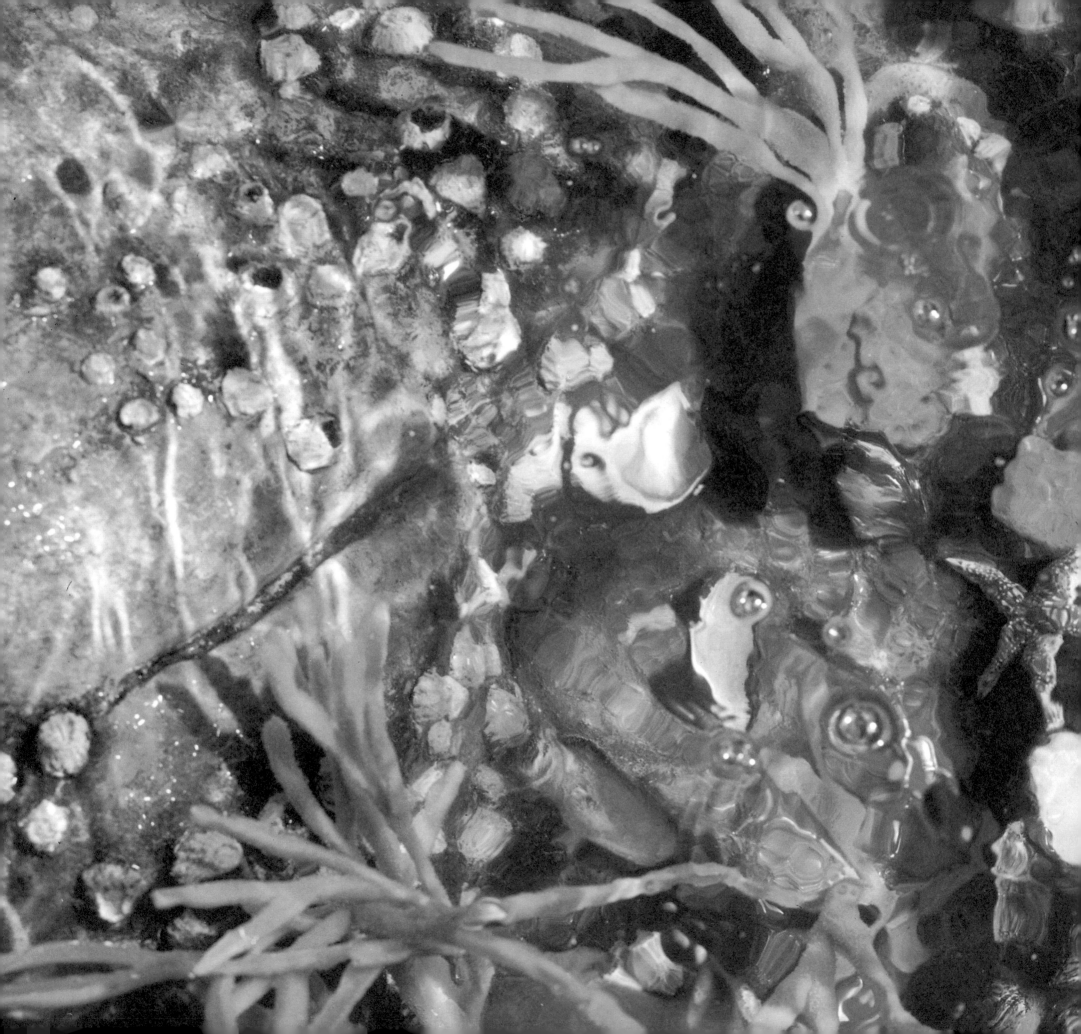